D1173849

Movie
MAGIC

FANTASTIC BEASTS
THE SECRETS OF DUMBLEDORE™

Movie MAGIC

Jody Revenson

INSIGHT 👁 EDITIONS

San Rafael • Los Angeles • London

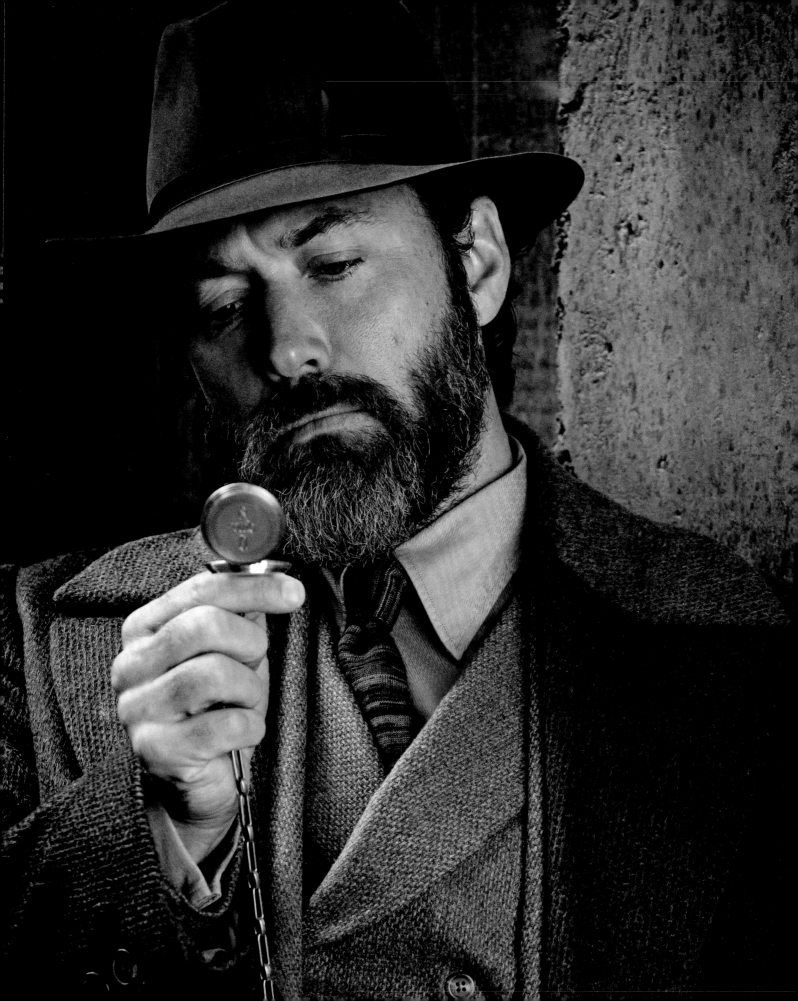

CONTENTS

Introduction: The Story So Far

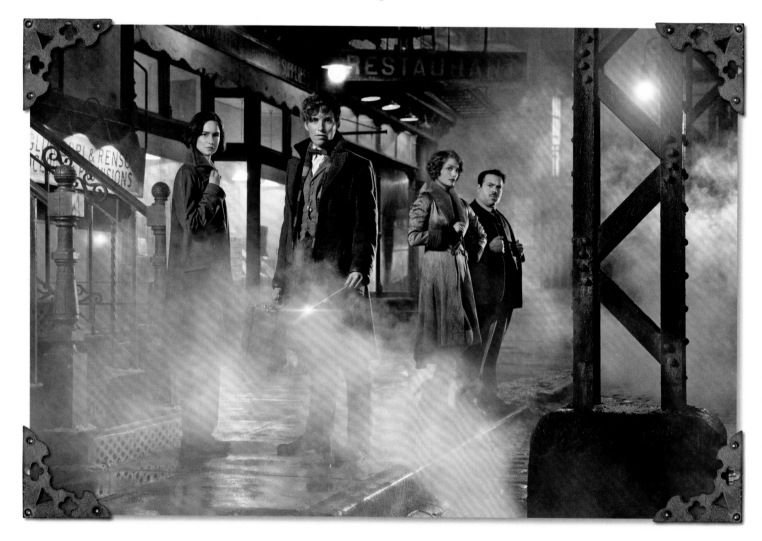

The wizarding world continues to expand in *Fantastic Beasts: The Secrets of Dumbledore*, after *Fantastic Beasts and Where to Find Them* introduced Magizoologist Newt Scamander, sisters Tina and Queenie Goldstein, and Jacob Kowalski, a No-Maj (non-magical) baker whose chance meeting with Newt in New York City sets the wheels in motion for the Fantastic Beasts series. Newt had been traveling the world doing research for his book before coming to New York City to return one of his creatures to the wild. A mysterious force was causing destruction in the city, and Newt discovered that it was an Obscurus. The source of the Obscurus—an unstable, parasitic Dark force that manifests violently when a child is forced to suppress their magic—was eventually discovered to be Credence Barebone, who was being abused by his adoptive mother. But during the battle to save Credence, Newt discovered that someone else was also hiding out in the city: the Dark wizard Gellert Grindelwald, who seeks dominance over Muggles and No-Majs.

As *Fantastic Beasts: The Crimes of Grindelwald* begins, the titular wizard escapes imprisonment while being transported to the British Ministry of Magic to go on trial for his crimes, and disappears.

Several months later, Newt is hoping to visit Tina and bring her a copy of his book, *Fantastic Beasts and Where to Find Them*, but he has been banned from travel by the British Ministry of Magic due to the calamitous events in New York. While pleading his case at the Ministry, he's reunited with his former close friend Leta Lestrange, who is now engaged to his brother, Theseus, who is Head of the Auror Office.

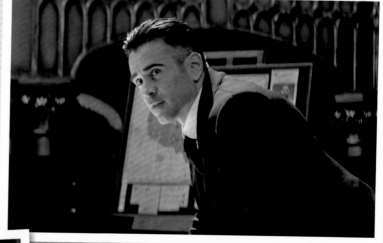

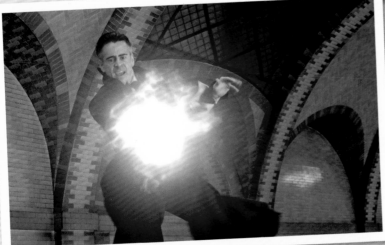

After the Ministry rejects his request, Newt meets with Albus Dumbledore, who informs him that Credence is in Paris and that a rumor has arisen that he may be Leta's lost brother. If Credence can be reunited with a member of his family, there is a chance he can be saved from the Obscurus. Newt himself must go investigate, as Dumbledore and Grindelwald made a blood oath while teenagers that they would never fight each other. The vial protecting this oath is in Grindelwald's possession.

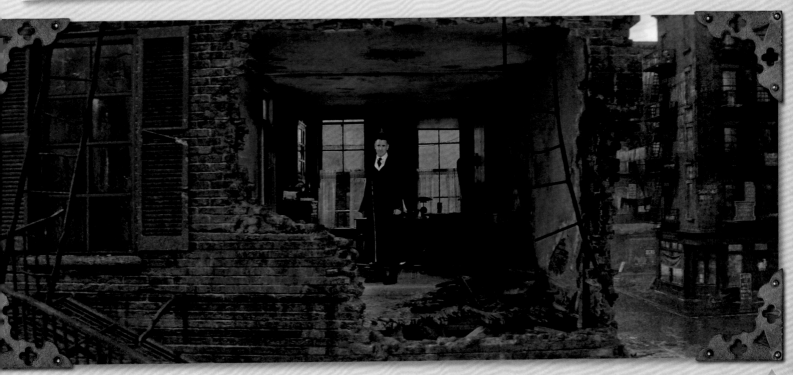

Queenie and Jacob unexpectedly visit Newt at his house, where he realizes she has put Jacob under an enchantment to get him to London in order to get married. Newt breaks the spell, leading to an argument between the couple. Queenie runs away to Paris to locate Tina, who is there searching for Credence. Newt and Jacob follow, and once there, realize Grindelwald is building support for his idea of the "greater good."

Tina locates Credence at the Circus Arcanus, but before she can approach him the circus is lit on fire. Credence escapes with Nagini, a woman who is cursed to become a snake. Stymied, Tina is approached by Yusuf Kama, who tells Tina he has proof of Credence's true identity. Newt and Jacob track down Tina, and they take shelter in the house of six-hundred-year-old alchemist Nicolas Flamel to plan their next steps.

Grindelwald has propositioned Queenie to join his cause and has promised her that, if he were to rule the wizarding world, he would do away with the rules that forbid her to marry Jacob. He also extends a personal invitation to Credence to a rally he is holding that night at the Lestrange mausoleum. Newt, Tina, Leta, and Kama also head to the mausoleum, where Kama reveals that he and Leta are half-siblings, and that Leta has a younger brother he believes is Credence. Leta is forced to confess that their brother was drowned when they were sent to America, so Credence cannot be her brother.

Following this stunning revelation, they attend Grindelwald's rally hoping to find Credence. He and Nagini are there, as is Queenie, who is briefly reunited with Jacob, and Theseus, who is there in his official capacity as an Auror. After stirring up his followers, Grindelwald casts a ring of fire through which only true believers can pass to join him. Credence walks through the fire as Grindelwald has promised him that he'll reveal his true identity. Queenie walks through believing Grindelwald's promises of living openly and loving freely. Leta valiantly attempts to stop Grindelwald, but he kills her and others, then Disapparates.

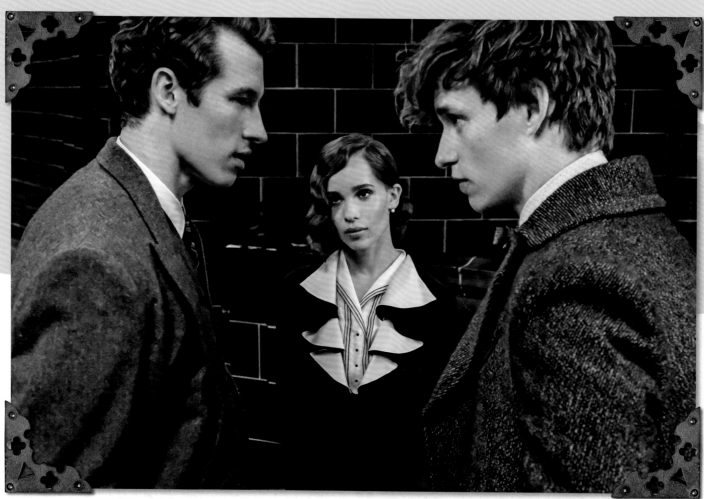

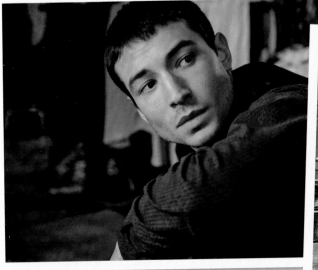

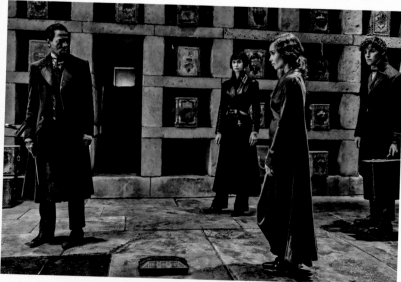

As the events of *Fantastic Beasts: The Crimes of Grindelwald* come to an end, Newt, Tina, Jacob, Theseus, Kama, and Nagini travel to Hogwarts, where Newt surprises Dumbledore with the recovered blood oath that he made with Grindelwald, which Newt's Niffler has stolen, in hopes that it can be destroyed. Concurrently, at his home, Nurmengard Castle, Grindelwald offers Credence a wand and reveals his true name: Aurelius Dumbledore.

Newt's next adventure, *Fantastic Beasts: The Secrets of Dumbledore*, is "a battle for the soul of the wizarding world," says producer David Heyman, "and also for the soul of the characters at the heart of this piece: Newt and his brother, Theseus; Dumbledore and his brother, Aberforth; Jacob and Queenie; Credence and Grindelwald; and, of course, Grindelwald and Dumbledore, whose relationship is really at the center of this film." The wizarding world continues to expand across the globe as *Fantastic Beasts: The Secrets of Dumbledore* introduces new magical communities, new beasts, and new wizards and witches, while also spending time in beloved places and with familiar friends. Before the final showdown, loyalties will be tested and errors of the past must be redressed or the consequences could prove devastating to Newt, Dumbledore, and the family these outsiders have created. So now, the story continues . . .

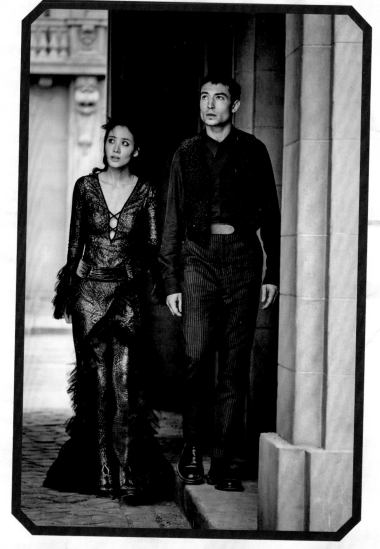

A Dream of London

Fantastic Beasts: The Secrets of Dumbledore opens with Albus Dumbledore dreaming of a reunion with Gellert Grindelwald. In the setting of a fashionable café in Piccadilly Circus, the two wizards discuss the blood oath they made as youths. Until recently, Grindelwald had the vial that contains the drops of their blood. It is now in Dumbledore's possession, regained by Newt Scamander via Teddy the Niffler.

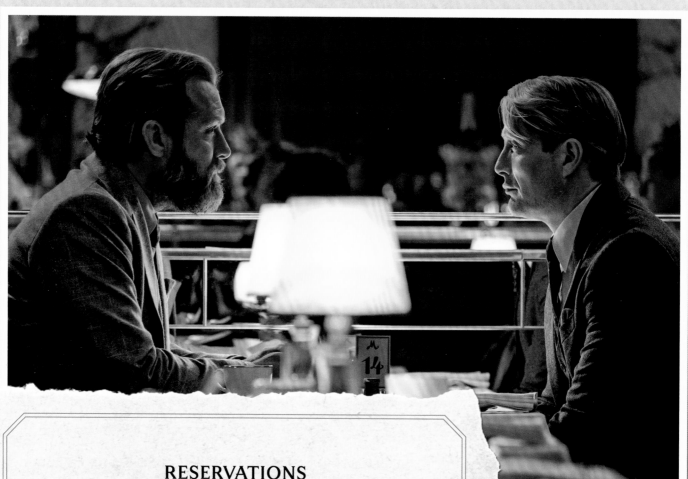

RESERVATIONS

The relationship between Dumbledore and Grindelwald is complex, but familiar; friendships and connections to loved ones are often redefined as people change throughout their lives. "It has to do with things that haven't been said, regrets, bonds of friendship, and forgiveness," says Jude Law (who plays Albus Dumbledore). "These are timeless themes and so enjoyable to play, because they're moving and bound to who we all are intrinsically as human beings."

The dream sequence between Dumbledore and Grindelwald was the first scene Jude Law and Mads Mikkelsen filmed together.

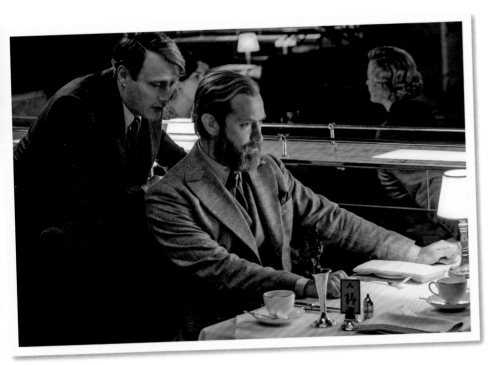

ENTRÉE

"It's always interesting when people meet up and one of them, at least, is carrying a grudge for so long," says Mads Mikkelsen (who plays Gellert Grindelwald). "The bitterness will come out in most peculiar situations, and it's hard to hide if your emotions are outside your shirt. Everything that comes out of your mouth will eventually be interpreted as a weakness, so I think Grindelwald is desperately trying to stay strong in [this] scene, and he just manages."

REPAST

"I think both of them had dreams," reflects Mikkelsen. "They were both very special students with very special talents, and they shared a common dream of making the world a better place. That lasted for quite a while and then it shattered, because their means to achieve the goal were not compatible." Mikkelsen describes this as "a tough breakup, and that it's been chasing Grindelwald, especially, since then."

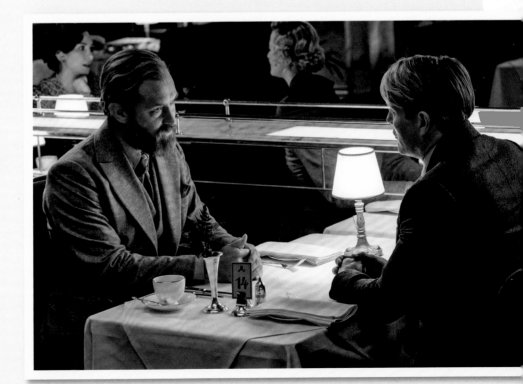

The Blood Oath

A blood oath is made between parties who enter into a binding magical pact by cutting their hands and sharing their blood. In their teenage years, Albus Dumbledore and Gellert Grindelwald score their palms with their wands and make a pact that one will never fight the other. A drop each of their blood rises and merges to create a singular droplet that is then encased in a vial.

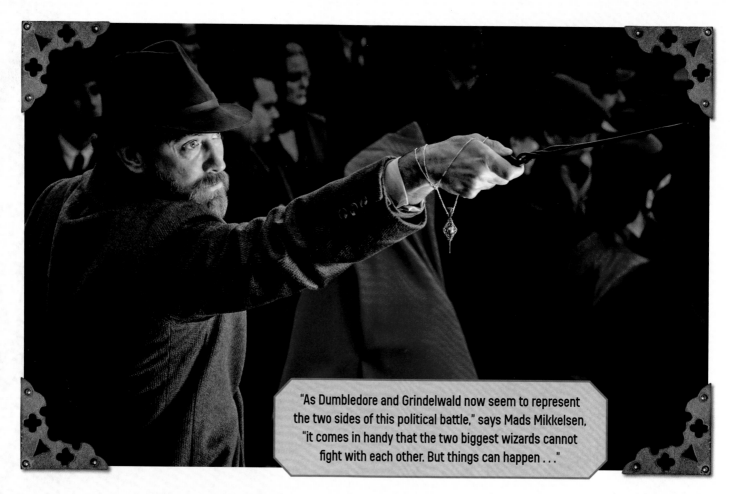

"As Dumbledore and Grindelwald now seem to represent the two sides of this political battle," says Mads Mikkelsen, "it comes in handy that the two biggest wizards cannot fight with each other. But things can happen . . ."

A WIZARD'S PACT

The meaning of the vial and the blood pact it carries is vital to *Fantastic Beasts: The Secrets of Dumbledore*. "As the storyline develops, we understand more the relationship between Dumbledore and Grindelwald," says prop maker Pierre Bohanna. "Inside its crystal center are two tiny drops of the gentlemen's blood, and the curse that neither can do any damage or any harm to [the] other while this charm exists."

HISTORY IN THE MAKING

Junior concept artist Molly Sole created the vial that Grindelwald carried with him in the second film, *Fantastic Beasts: The Crimes of Grindelwald*. At the end of that film, the vial is taken by Teddy the Niffler, and Newt later gives it to Dumbledore. In regard to the design of the vial, "most of the time, the objects [in the wizarding world] have a context that's already been established," says Sole. "We need to understand the history of it before [we] can take it forward or, in this [case], take it backward in time."

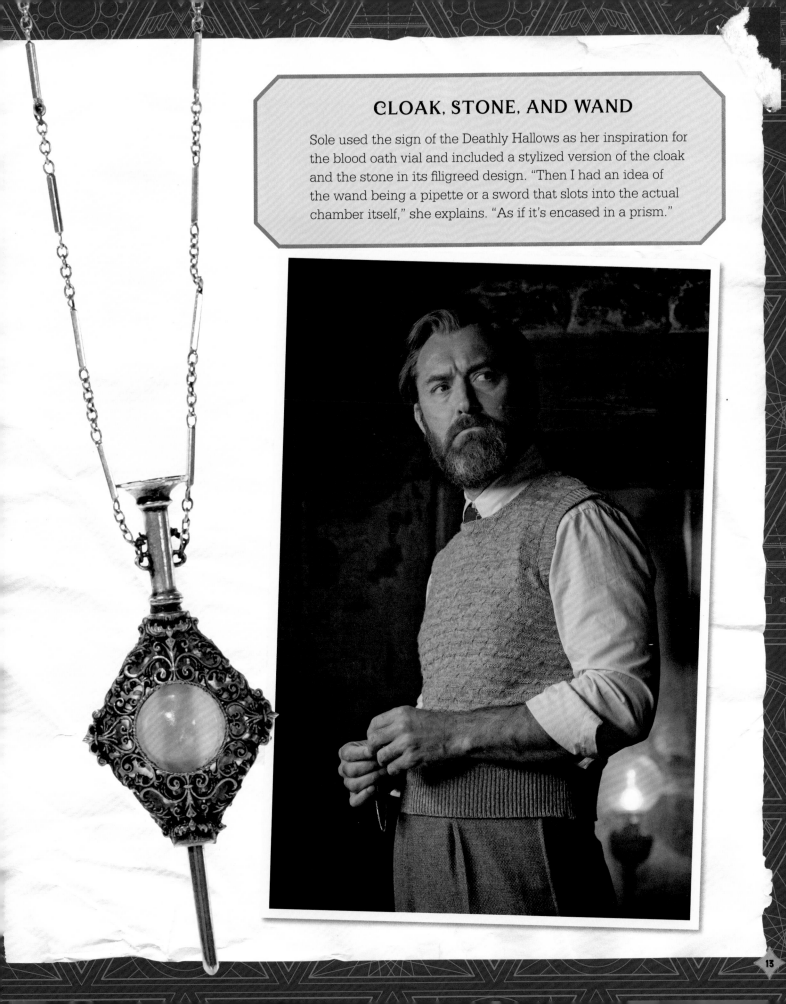

CLOAK, STONE, AND WAND

Sole used the sign of the Deathly Hallows as her inspiration for the blood oath vial and included a stylized version of the cloak and the stone in its filigreed design. "Then I had an idea of the wand being a pipette or a sword that slots into the actual chamber itself," she explains. "As if it's encased in a prism."

Newt Scamander

At a time of great change within the wizarding world, Magizoologist Newt Scamander finds himself tasked to go on what actor Eddie Redmayne (who plays Newt) describes as "a Dumbledorian quest." First, however, Newt must find and retrieve a mythical beast in the wilds of China.

YOUR WILDEST DREAMS

"Something I've been begging director David Yates to do was to allow us to see Newt out in the wild," says Eddie. "I always wanted to see him in the environment in which he feels his most comfortable; it's an environment in which he loves his life the most. I was thrilled when I saw we would get to see him doing just that."

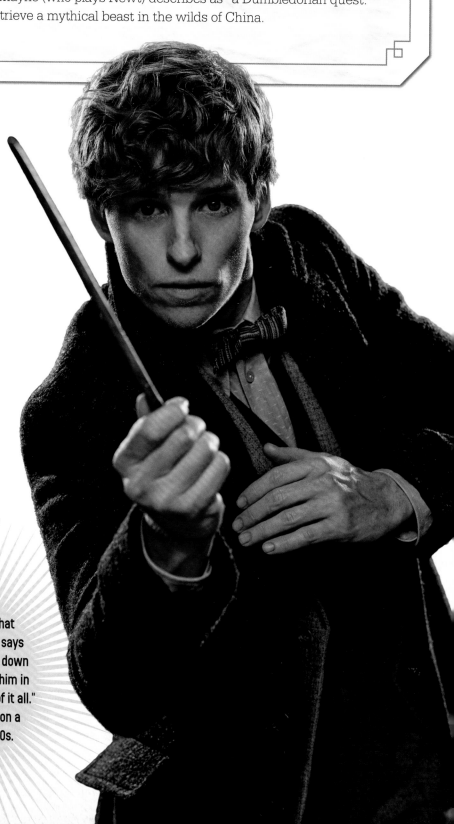

"Newt has a bow tie that he doesn't really wear," says Colleen Atwood, "but it's down around his neck to keep him in character with the Newt of it all." Newt's tie was knitted on a machine from the 1930s.

LOOKING THAT WAY

At the start of each Fantastic Beasts film, costume designer Colleen Atwood and Eddie Redmayne get together to consider whether Newt should wear a different tie or a different trouser leg, "and we always end up going back to the same silhouette," says Eddie, "because weirdly, if you put a normal tie on Newt, he just doesn't look like Newt anymore."

FIRST LOOKS

"He starts in a beat-up linen, three-piece, safari-meets-Newt suit," says Colleen Atwood. "In this unique environment, you'll see Newt without his jacket, because he's working; he's got his waistcoat and a shirt with sleeves rolled up." Newt goes through so much action in the sequence that more than a dozen versions of this costume were made, as the different scenes required different stages of wear and tear.

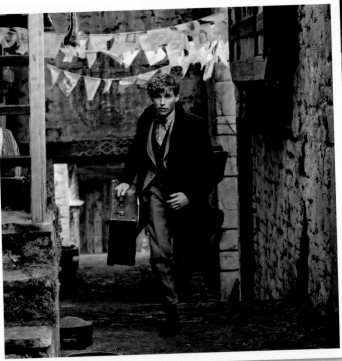

FOLLOW THE LEADER

"After his return [from China], Newt is given responsibility by Dumbledore to head up a team," says Eddie Redmayne, "and given he's not at his most comfortable being a leader, he's forced to step it up a bit. I think Dumbledore's giving it to him as a challenge out of necessity, but also to keep his protégé growing. And Newt discovers new qualities in himself through that."

Tianzi Mountains

A new Head of the International Confederation of Wizards is to be elected, which involves more than a candidate's promises and supporters. A mythical creature—the Qilin—chooses the new leader thanks to its inherent ability to perceive a person's true character. Newt Scamander is sent to find this extraordinary creature and bring it back to Dumbledore.

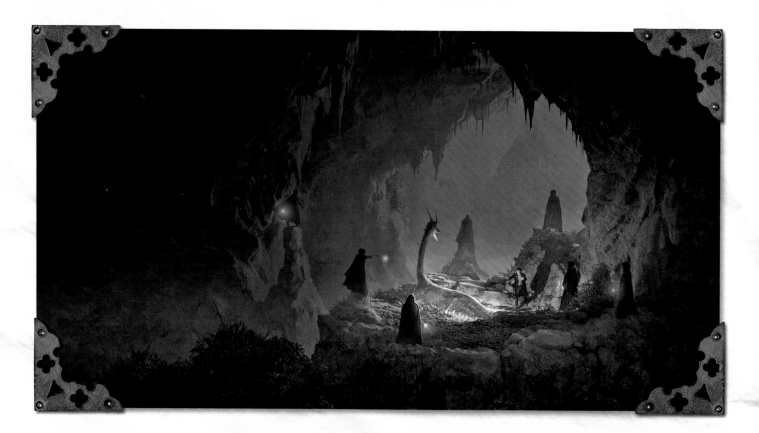

HAVE CASE, WILL TRAVEL

Our first look at Newt is in the Tianzi Mountains in China, on his own, putting all his tracking prowess to its best use. "One of the things that I love about this film is you finally get to see Newt where he's at his best and happiest: tracking creatures," says Eddie. "And in this case, it's a very beautiful creature called a Qilin."

WATER FALLS

The massive cascades of water in the Tianzi Mountains were based on Detian Falls, said to be the largest waterfall in Asia, on the border of Southern China and Vietnam. "The location is just phenomenal, with statuesque limestone walls and a broad, meandering river," says Neil Lamont, co-production designer. "But could we make a waterfall like that at the studio? Is that even going to be possible? And the crew said, of course it's going to be possible."

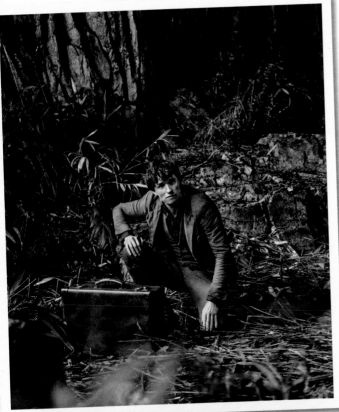

ALL WET

"Everybody agreed that the waterfall set was amazing," says visual effects supervisor Christian Manz, "even though I was concentrating more on making sure the water wasn't about to tip into my boots! It's only when you turned around and you saw cars and cranes you'd remember, 'Oh. We're still in the studio.'"

REAL DEAL

Of the first time Eddie Redmayne saw the Tianzi Mountains set, he says, "My mind was fully blown. It had to be seen to be believed. They had these gigantic pumps—of which there are only ten in the world—pumping water up and down to create the waterfalls. Even when you were there and it was happening, you couldn't quite believe it was real."

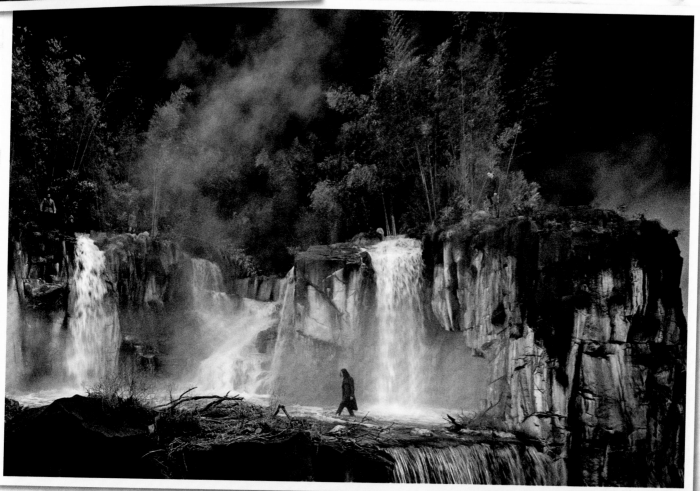

New Beasts: Qilin

The Qilin has the capacity to look into a person's soul and see if they have true goodness. This revered mythological Chinese beast, used to help find leaders within the wizarding world, bows before those with the right moral code and strength of personality to rule. The Qilin bows before very few people.

A FABULOUS BEAST

In Chinese mythology, the Qilin has been visualized as a dragon with scales, as being deerlike, and sometimes as having a lion's head. "We went down the route of deer," says VFX supervisor Christian Manz, "which is not a traditional look, but because we felt the audience could relate to that." This Qilin was also influenced by the look of a dik-dik, a tiny antelope with a snout almost like an anteater's.

Christian Manz estimates they may have gone through three hundred concepts for the Qilin before deciding on its final look.

"As the Qilin is a relative newborn, director David Yates wanted it to be a bit puppylike and naughty," says Christian Manz. "Then, at that one moment it bows to the new leader, it's got the necessary dignity—that was really nice and fun to play with."

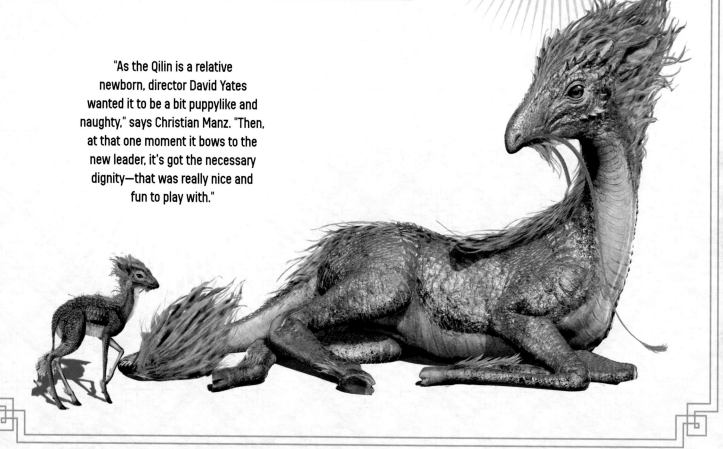

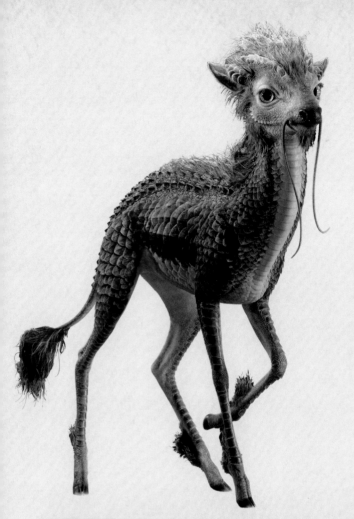

MOTHER NATURE

"When we find Newt at the beginning of the film," explains Eddie Redmayne, "we meet a mother Qilin giving birth. The baby Qilin is incredibly beautiful and fragile. They're foal-like, with an inner light that glows and a wonderful, gentle cry." Redmayne found the birth of the Qilin one of the more intense scenes of the film to shoot. "The puppeteers were not only moving the Qilins and the puppets but making the sound effects. It really felt like you were there for the birth of something special."

PARTS TO PLAY

Tom Wilton puppeteered the Qilin puppet on the set of *Fantastic Beasts: The Secrets of Dumbledore*, using rod attachments on her legs and back for movement and different heads, including one with a moving mouth. Additionally, "she lights up!" he says. "This is part of her spirit when she finds a wizard or witch who is worthy. She can approach them and bow, and the ground is suffused with a nice glow."

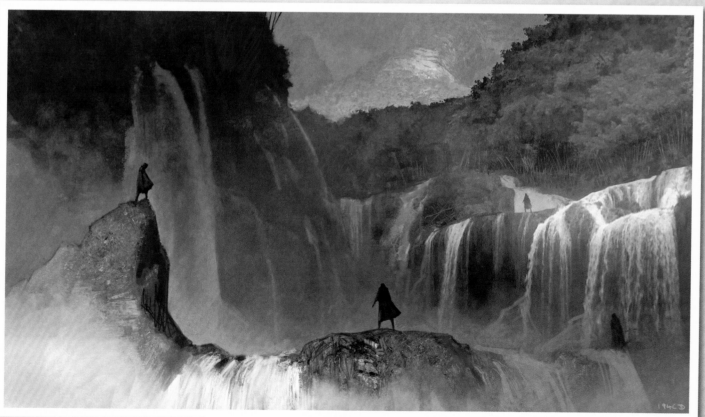

A Qilin's Rescue

Just after Newt witnesses the birth of the baby Qilin, he's attacked by a band of Grindelwald's acolytes, including Credence Barebone, who are also looking for the Qilin. In order to save the newborn, Newt slides through a thick bamboo forest only to land in a pool of water.

DROP INTO PLACE

"When Newt rescues the baby Qilin, he dives over the edge of the forest and plummets down," says puppeteer Tom Wilton. "We did some really exciting work with stunts where they were essentially puppeteering the camera. They had it on wires coming down, moving very fast. Our Qilin puppet was flat-out going down this steep gradient. That certainly put me through my paces!"

The bamboo-covered hill Newt slides down was built on a massive scaffolding, forty-five feet high and one hundred feet long.

WET IN THE WILD

"There's a big action sequence that involves Newt being thrown over waterfalls and into a pool of water," says Eddie Redmayne. "And then I had to swim or lie in a lake, in November, in England, for several nights, which was not comfortable!"

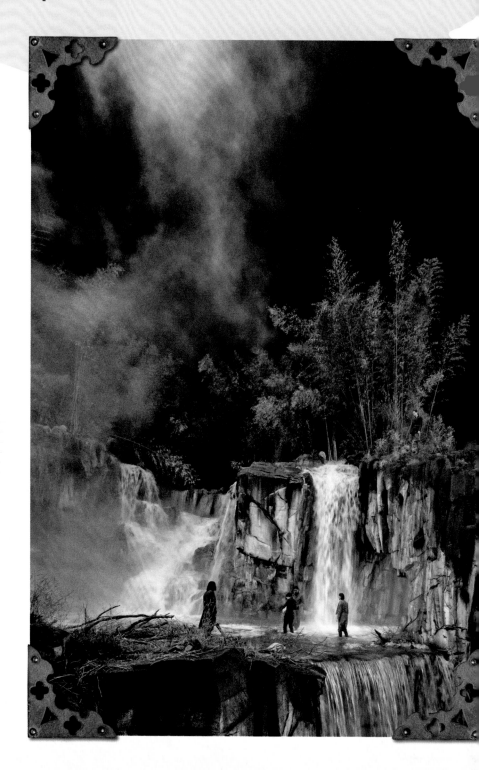

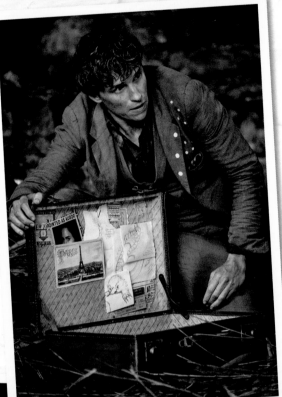

NATURAL MAGIC

"Something that I've always found unique about Newt in relation to many of the other heroes from the wizarding world is that he's not written as the greatest or most powerful wizard," says Eddie Redmayne, "but he [has] his own unique facility with magic." When Newt duels Credence to secure the Qilin, Newt uses the organic matter around him for the spells; for example, sending leaves into whirlwinds or shields. Director David Yates describes this as "Newty" types of magic. "It may not be the most impressive," Eddie adds, "but it feels more specific to who Newt is."

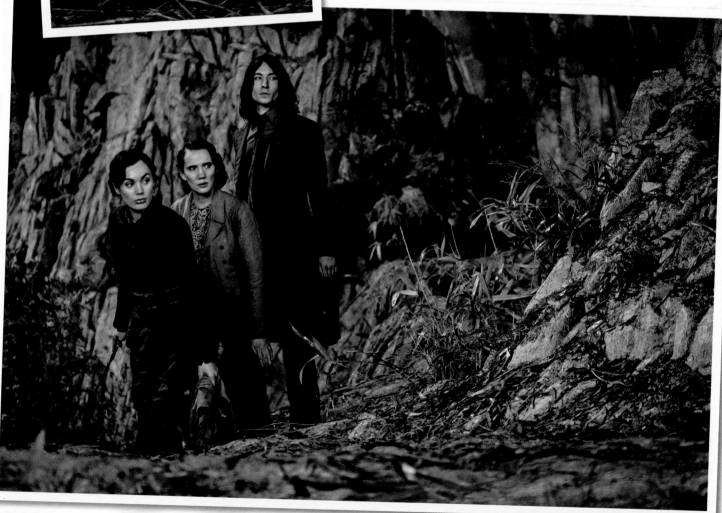

New Beasts: Wyvern

After Newt recovers the baby Qilin in China, he's battered and unconscious, having fought with Grindelwald's acolytes, including Credence. A Wyvern helps him escape. "The Wyvern has a pretty seminal role in an early moment in the film," says Eddie Redmayne.

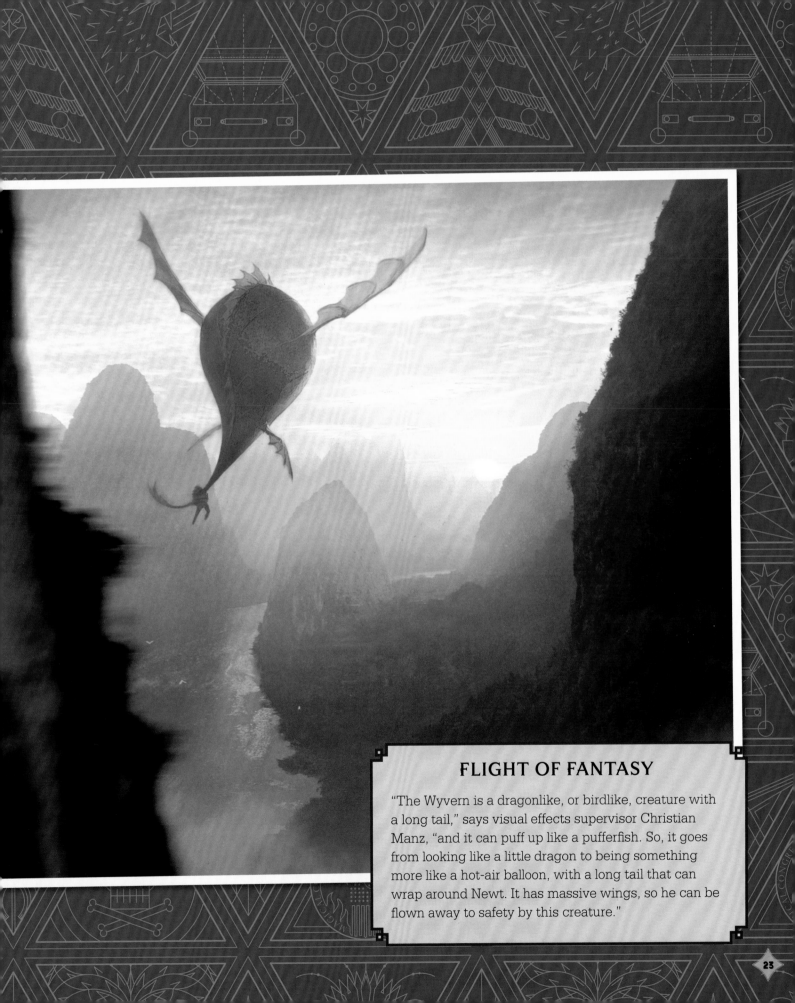

FLIGHT OF FANTASY

"The Wyvern is a dragonlike, or birdlike, creature with a long tail," says visual effects supervisor Christian Manz, "and it can puff up like a pufferfish. So, it goes from looking like a little dragon to being something more like a hot-air balloon, with a long tail that can wrap around Newt. It has massive wings, so he can be flown away to safety by this creature."

Nurmengard Castle

In *Fantastic Beasts: The Crimes of Grindelwald*, Grindelwald gifts Credence with a new wand and his real name in the grand drawing room of his residence, Nurmengard Castle, which is surrounded by breathtaking views of the Austrian mountains. Nurmengard Castle was also seen briefly in *Harry Potter and the Deathly Hallows – Part 1*. For *Fantastic Beasts: The Secrets of Dumbledore*, several important sequences take place in the castle courtyard, and so an expansion of the castle was warranted.

Set decorator Anna Pinnock describes Nurmengard Castle as "a Dark wizard's home, isn't it?"

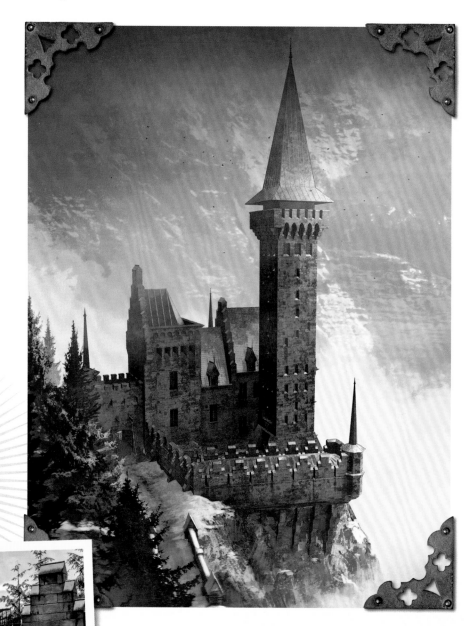

SOLID AS A ROCK

As towering as the mountains that surround it, the many storied Nurmengard Castle is set in a rough-hewn rock escarpment. The Gothic style of Nurmengard Castle, established in its previous two appearances, "links it with Harry Potter quite a lot, for that reason," says co-production designer Neil Lamont.

BUILDING OUT

A courtyard, created by production designer Stuart Craig, was added to Nurmengard Castle for *Fantastic Beasts: The Secrets of Dumbledore*. "They had developed quite a lot of that exterior, along with the bridge and the gatehouse, in the second film," says Neil Lamont. An open area beyond the courtyard and away from the castle's walls was also created, where Credence flies his phoenix.

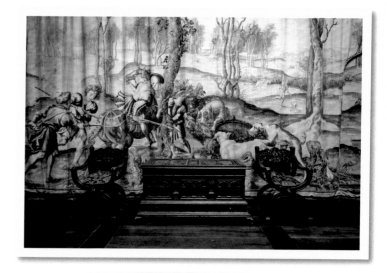

A tapestry room features six panels encircling the walls that tell the story of a boar hunt.

A ROOM OF HIS OWN

Credence's room in the castle was originally designed to be "a plain space, almost like a spare room," says set decorator Anna Pinnock. Then director David Yates asked for it to be more of a visual representation of his character. "So, we had to get across his descent into madness," says Pinnock. "We put feverish writing in chalk on the floor and the walls, the glass windows were cracked and leaves were coming in, there were plates of food on the floor, the bed was unmade. It showed the state of his world."

Gellert Grindelwald

According to actor Mads Mikkelsen, who plays Gellert Grindelwald in *Fantastic Beasts: The Secrets of Dumbledore*, Grindelwald is still trying to carry out his ambition "for the greater good." "Grindelwald is a man who wants to make the world a better place," says Mads, "*if* they follow his lead. The means by which he wants to achieve that is not necessarily what everybody else agrees on."

FRIEND OR FOE

When we meet Dumbledore and Grindelwald in this film, they are obviously adversaries, "but they also have a past when they were young," says Mads, "and they had a common goal. They both wanted to make the world a better place, so they united for that and created some very strong bonds. Then their ways were separated."

GOOD LOOKS

Costume designer Colleen Atwood describes Grindelwald as "a man who's walking among the Muggles," and so she wanted to give the character a look that he could get away with on the street without turning too many heads. Atwood dressed him in luxurious fabrics in a classic and elegant style. "He's a man of great power, but that doesn't mean he should wear flashy clothes," she says. "He could blend in in any room, or he could stand out in any room; that was the goal."

The majority of Grindelwald's costumes are in a color called loden green. He wears a straightforward men's chesterfield-style coat, "the least wizard-like coat of anyone, to contrast him to the world he's of," says Colleen Atwood.

ADVANTAGE GRINDELWALD

"Grindelwald is a master manipulator," says Alison Sudol (who plays Queenie Goldstein), "and the thing about master manipulators is that they understand the human psyche and, unfortunately, use it. He finds Queenie in a vulnerable state and tells her what she wants to hear. He's clever, that one, and that's why he's so dangerous."

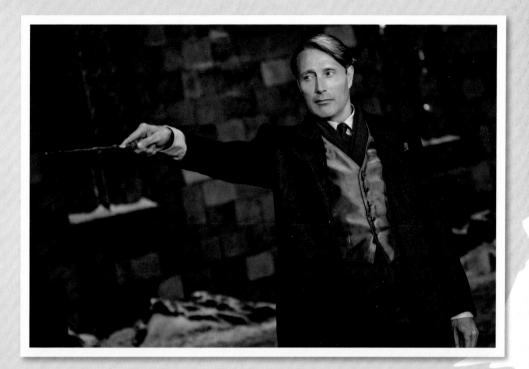

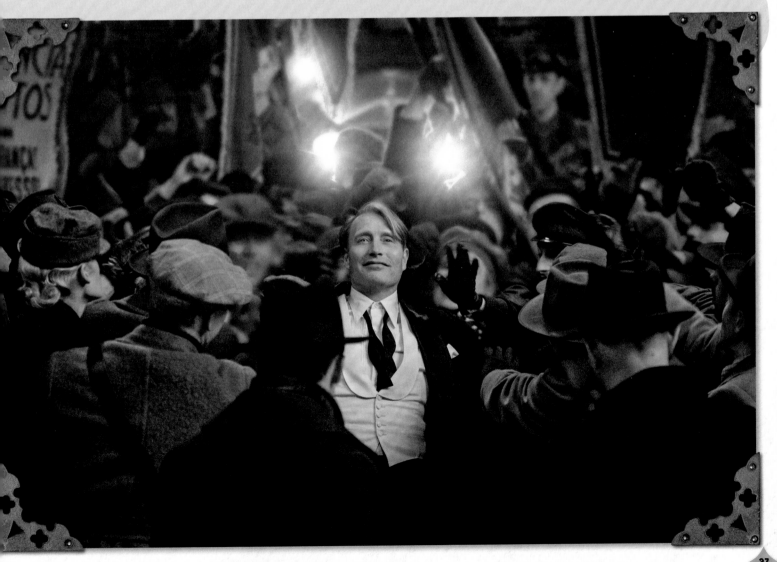

Queenie Goldstein

"Queenie went through quite a shocking transition in the second film," says Alison Sudol, who plays Queenie. "I think it took a lot of people by surprise, including myself. She ends up making a fairly rash decision to follow a very manipulative human being, but one she believes offers a change she needs. Now we find her in a dangerous environment with nobody who can protect her."

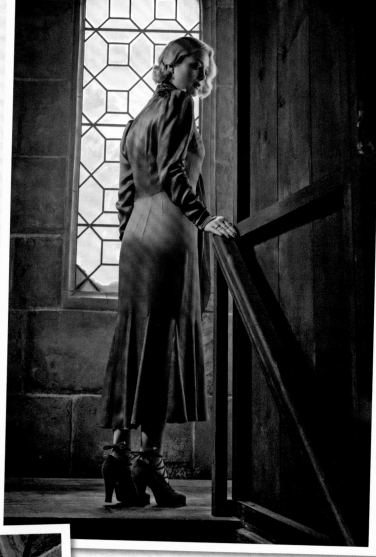

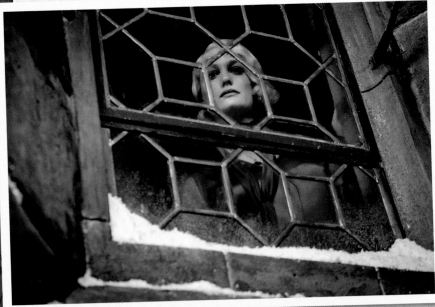

IN THE RED

Since Queenie is living in Nurmengard Castle, Colleen Atwood chose a Germanic silhouette for her wardrobe, but with color in her costumes "to show she is not totally in that world, but a little bit outside it," Colleen explains. "We used a deep carmine red on her, which contrasted nicely with the choice of her super-platinum hair." The tones of the other outfits Queenie wears are different variations of this red color. "She goes into a Bing cherry red later on, as the story becomes more occluded."

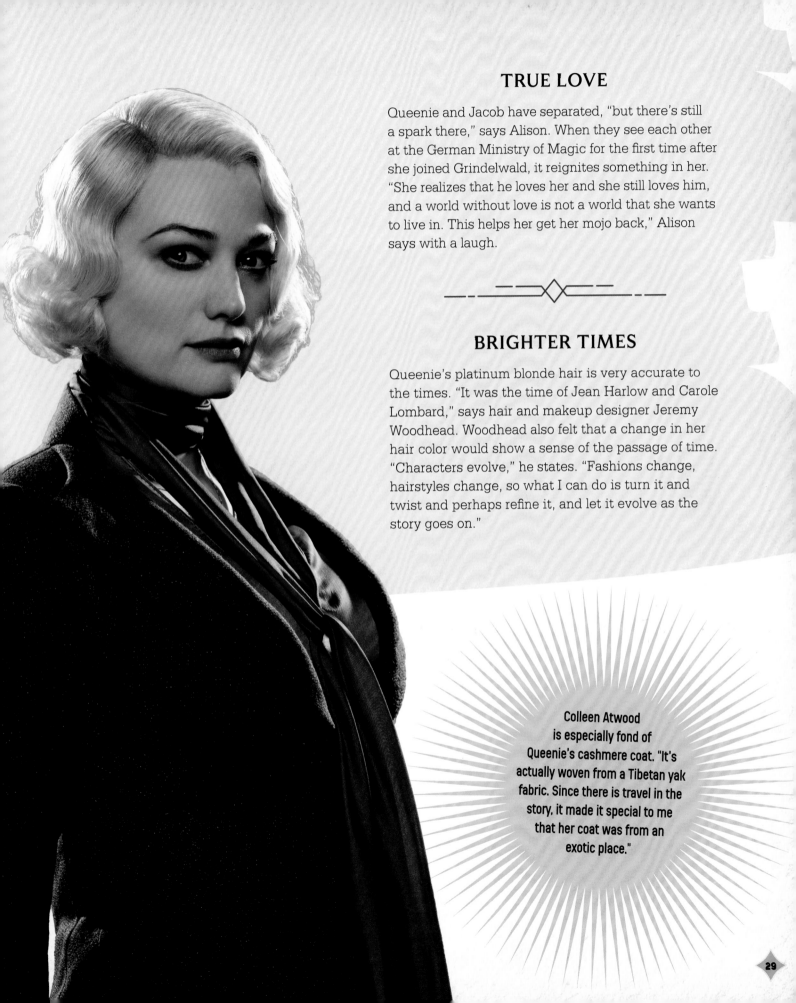

TRUE LOVE

Queenie and Jacob have separated, "but there's still a spark there," says Alison. When they see each other at the German Ministry of Magic for the first time after she joined Grindelwald, it reignites something in her. "She realizes that he loves her and she still loves him, and a world without love is not a world that she wants to live in. This helps her get her mojo back," Alison says with a laugh.

BRIGHTER TIMES

Queenie's platinum blonde hair is very accurate to the times. "It was the time of Jean Harlow and Carole Lombard," says hair and makeup designer Jeremy Woodhead. Woodhead also felt that a change in her hair color would show a sense of the passage of time. "Characters evolve," he states. "Fashions change, hairstyles change, so what I can do is turn it and twist and perhaps refine it, and let it evolve as the story goes on."

Colleen Atwood is especially fond of Queenie's cashmere coat. "It's actually woven from a Tibetan yak fabric. Since there is travel in the story, it made it special to me that her coat was from an exotic place."

Credence Barebone

Actor Ezra Miller describes what is happening with his character, Credence, during the events of *Fantastic Beasts: The Secrets of Dumbledore* as a double-edged sword. "He's been given a sense of identity and purpose," says Ezra. "He's been acknowledged in his power by Grindelwald and has been a favored child in this cult, but the way that he came to be in this position haunts him. And he's catching on to the fact that he's been deceived."

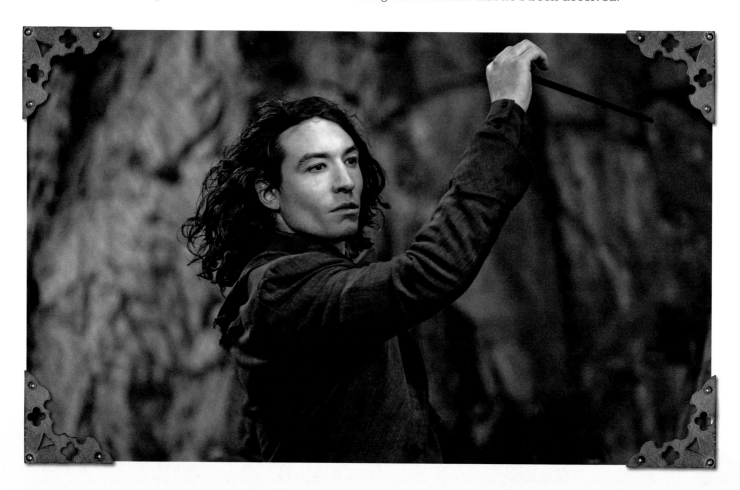

SAVED FOR A SPECIAL OCCASION

Credence is first seen in the mountains of China in search of the Qilin, wearing a simple, dark, hooded coat "in humble materials, as everyone else would be wearing in a jungle," says Colleen Atwood. Back in the urban worlds of Nurmengard and Bhutan, Credence wears a waistcoat made from a Japanese lacquered fabric Atwood had been carrying around for twenty years. "It finally found its life in this film," she says. "It's an absolutely amazing fabric, because even though it's dark, it reflects light and the colors of the rainbow."

AT GREAT LENGTH

Since *Fantastic Beasts: The Crimes of Grindelwald*, Ezra Miller had grown out his hair. "He arrived [on set] with his hair down to *here*," Jeremy Woodhead says with a gesture, "and he looked fantastic and unworldly, as if he'd been locked in a cupboard for five years and the magic world had passed him by." Though this style is not particularly accurate for the time, "We all agreed it worked perfectly for his character—it was completely at odds with everybody else."

Credence has been able to carry his power as an Obscurial for a preternatural amount of time, but "it's corroding him from within," says Ezra. "The premise of the Obscurus itself is that it's deeply destructive, initially attacking the outside world. I think what we are witnessing now is that it starts to attack the host body itself."

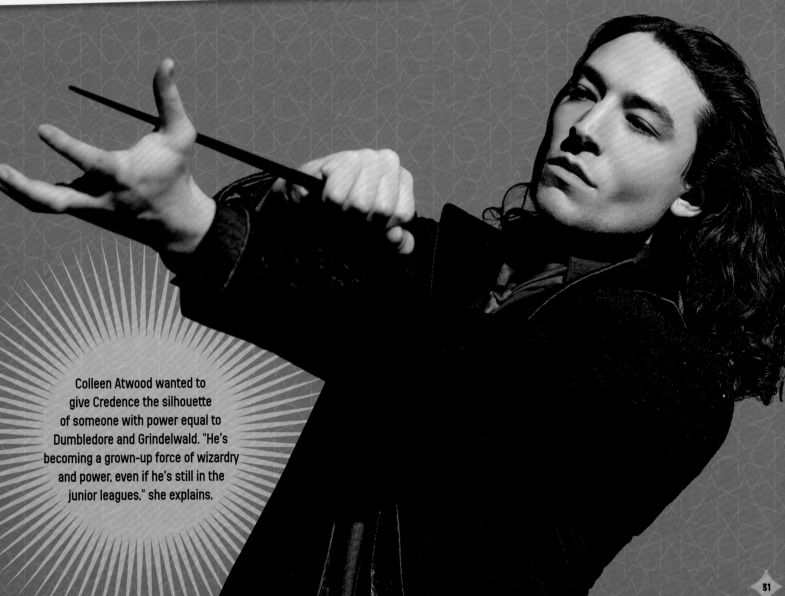

Colleen Atwood wanted to give Credence the silhouette of someone with power equal to Dumbledore and Grindelwald. "He's becoming a grown-up force of wizardry and power, even if he's still in the junior leagues," she explains.

Albus Dumbledore

"It's pretty unique playing a character who has such a rich backstory *and* future story already in existence that you can draw upon," says actor Jude Law. "In the second film, I was able to tap into that momentarily. I think you understand a little more at the end of this story about why he is who he is, the sacrifices he's made, and the demons that he's had to face."

ALBUS DUMBLEDORE

PAST MASTER

Jude Law explains that the man we grew to love through the Harry Potter films is not fully formed yet, "so what we're seeing is an Albus going through big emotional situations and making life-changing decisions. These lead him to become the headmaster we see in later years. But to become that learned and wise costs. We're seeing him confronting his past, confronting old friends, old foes, and also confronting himself."

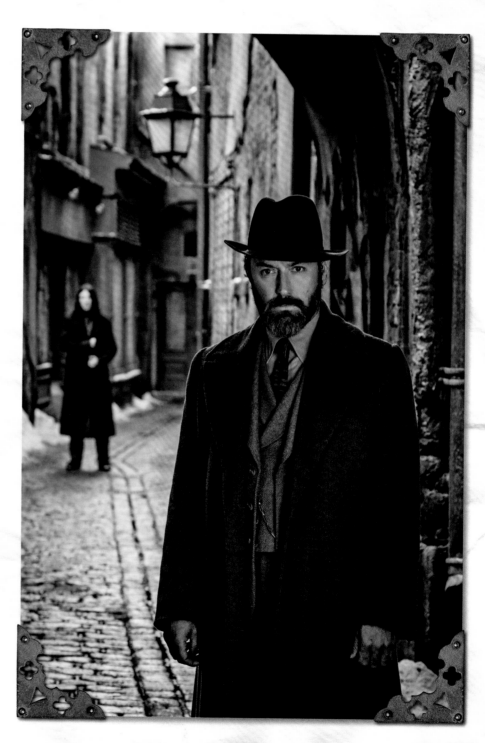

COMFORT ZONE

"People oftentimes repeat the styles that they've worn before, modifying them a little bit, which was the concept with Dumbledore," says Colleen Atwood. Dumbledore's wardrobe might be a bit more refined than seen in previous appearances, with luxurious material and fabrics, "but we stayed with comfort and with tweediness," she says.

— — ◇ — —

BACK AND FORTH

Hair and makeup designer Jeremy Woodhead found it a bit odd working backward when creating Dumbledore's look. "We know how Dumbledore ends up fifty years in the future, but this was showing the first stage of the evolution to that. His hair and beard are slightly longer than everybody else, anticipating what might happen to him down the line."

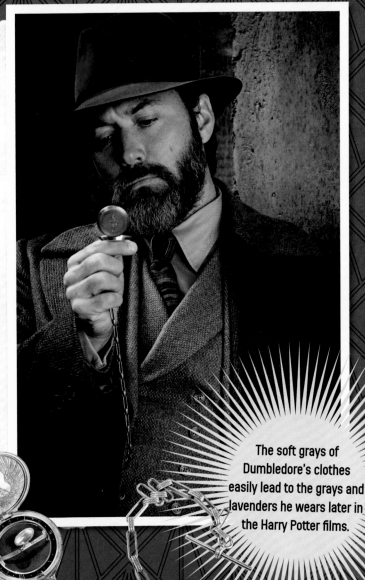

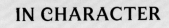

The soft grays of Dumbledore's clothes easily lead to the grays and lavenders he wears later in the Harry Potter films.

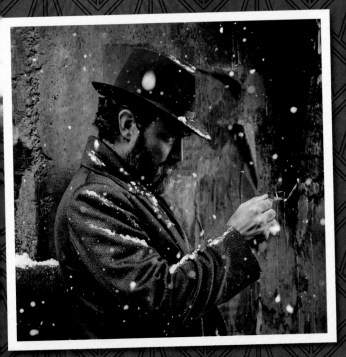

IN CHARACTER

"What I love is the enigma of Dumbledore," says Eddie Redmayne. "He's got this spark. He's got this playful quality to him while dealing with stakes that are ridiculously high. And Jude Law has that in spades. He has this twinkle in his eye and this really capricious quality to him."

Return to Hogwarts: Dumbledore's Office

Professor Albus Dumbledore's office at Hogwarts is much smaller than the one later visited in the Harry Potter films. It may not have three circular levels or shelves and shelves of books, but it easily reflects the welcoming nature of this beloved teacher.

"There's something quite quaint and homely about Dumbledore," says Anna Pinnock, "as well as being an urbane wizard."

TIME AND PLACE

The Dumbledore in *Fantastic Beasts: The Secrets of Dumbledore* is not yet headmaster, so his office in not atop the highest tower, as it is in the Harry Potter films, but production designers Stuart Craig and Neil Lamont endeavored to give it the same vibe. "It's in a turret, and has the same style of cabinetry," says Lamont.

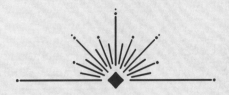

SET OF SELF

Set decorator Anna Pinnock decided that perhaps Dumbledore gave tutorials in his office. "That gave us an excuse for all the school stuff," but she notes that "he also keeps his snowshoes in there and his kettle by the stove." Instead of a desk, Dumbledore works on a round table that is stacked with students' class assignment notebooks (color coded by house), end of term reports, letters from fellow professors, and a page on knitting patterns. Astrological and astronomical pieces show the interests he has as a young man that carried through his life.

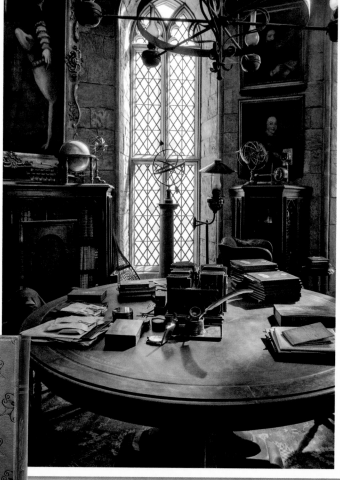

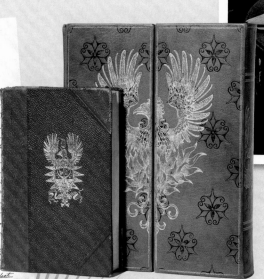

"Hogwarts is a place where Dumbledore feels most at home," says Jude Law. "It's his sanctuary from the world."

AFTER AND BEFORE

"I always feel a great mantle of responsibility to the fans," says Anna Pinnock. "I do take a lot of care to preserve the spirit of what's been done before, but obviously, the Fantastic Beasts stories are set much earlier, so we can take some artistic license." Pinnock avers that the philosophy is to preserve the character of what is seen in the Harry Potter films, but embellish and put their mark on it.

Theseus Scamander

"At the beginning of the film, we find Theseus in a moment of change," says Callum Turner, who plays Newt's older brother. "Up until this point, he's been quite clear on his intentions and how he wants to do good for the wizarding world, but with the loss of his fiancée, Leta Lestrange, he realizes he has to be more flexible and find a new route to fight the good fight."

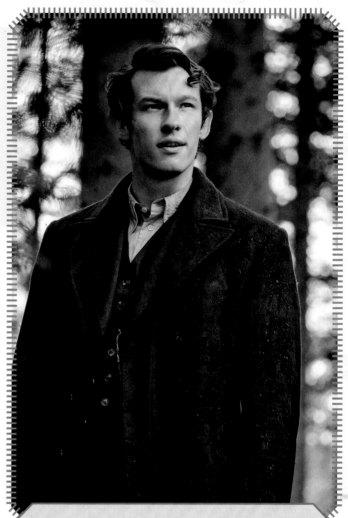

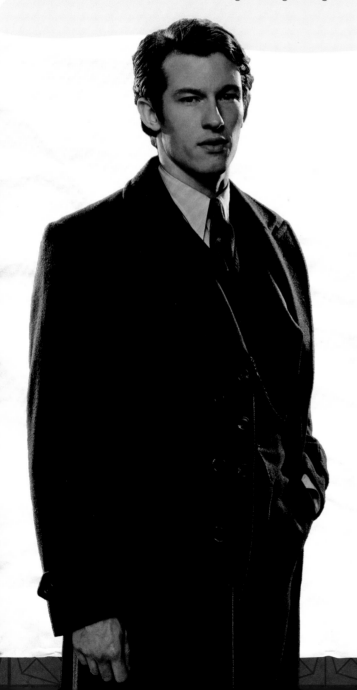

"Theseus is determined to get justice, after Grindelwald killed Leta," says Callum Turner. "He doesn't know how that will manifest, but he's going after it."

GOOD INTENTIONS

Costume designer Colleen Atwood sees Theseus Scamander as "the honest cop in the show." To portray this, his coat and suit were made in a navy blue, "because, to me, it's a really refined version of a uniform. He's definitely a guy with the best intentions of everyone at heart, and I think that his character conveys that." Colleen kept his costume very simple so that "it would be about who he is and what his objectives are."

IN GOOD REPAIR

Callum Turner appreciates that the Scamander brothers have become closer than ever. "They're reentering a stage in their relationship they probably haven't been in since they were kids," says Callum. "They're trying to be more open with the other," although Callum thinks Theseus may be a little bit more open than Newt. "But they're repairing what they can and developing a new understanding and respect for the way the other person thinks."

CHALK AND CHEESE

Eddie Redmayne recognizes the differences between Newt and Theseus: "Newt is not a social animal; he's much more at ease with his creatures. He's not someone who's good at being part of the system, and he didn't really fit in at school. Whereas, Theseus is very much the schoolboy hero, who's gone into a life within the Ministry, was a war hero, and has a facility with people that Newt doesn't: They're chalk and cheese. Yet, because they need to work together, they realize that they complement each other quite well."

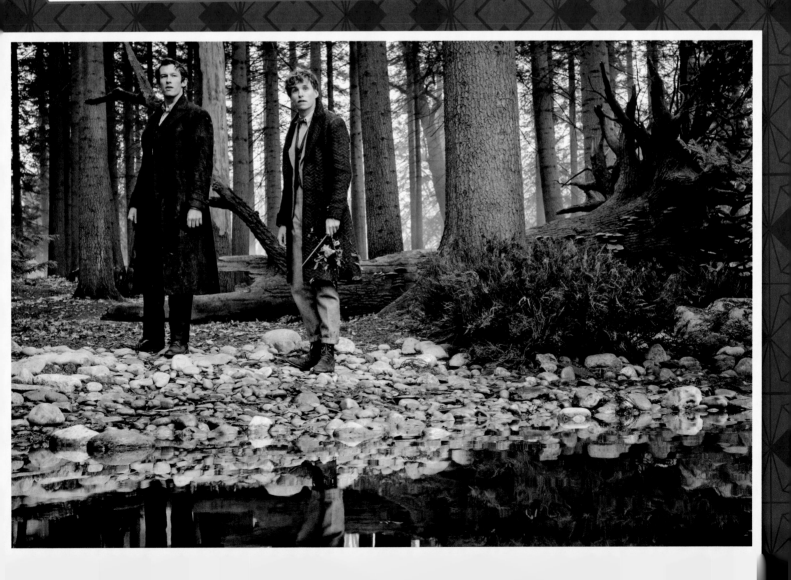

Return to Hogsmeade

Newt and Theseus join Dumbledore at the Hog's Head Tavern and Inn to learn the consequences of the blood oath between Dumbledore and Grindelwald, and a possible way to stop Grindelwald from achieving his ambition of taking over the wizarding world.

SNOW DAY

"Getting to walk to Hogsmeade in the snowscape, with Callum Turner playing my brother, was wondrous," says Eddie Redmayne. "They created this huge, roaring fire inside the Hog's Head Inn, in this battered, beautiful old pub. It was pretty wonderful, that day. Callum and I really wanted to get a drink and settle in for the evening."

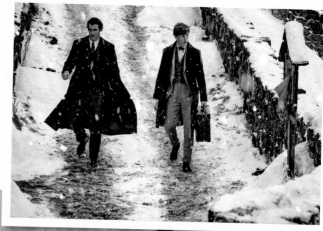

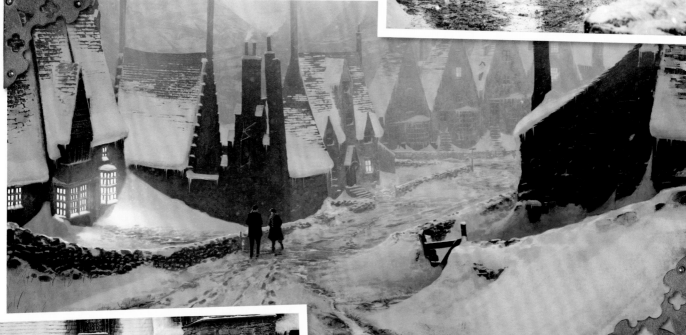

INSIDE OUT

The exterior of the Hog's Head Tavern and Inn is seen for the first time in *Fantastic Beasts: The Secrets of Dumbledore*. "It helps your understanding of its proximity to Hogsmeade so much better," says co-production designer Neil Lamont. "It narrows the gap between the Hog's Head and the town itself, which I think is a good thing."

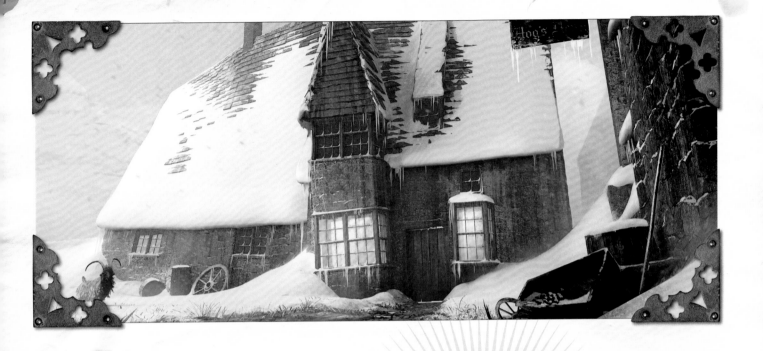

COLD COMFORT

Hogsmeade's buildings have a post-and-beam construction, based on seventeenth-century Scottish architecture. As the town is perpetually covered in snow, the architecture is fashioned for warmth, with thick granite walls and small windows. Crowstep gables provide a way to get onto the roofs to maintain the chimney stacks, which are constantly in use. Like much of wizarding architecture, the Hogsmeade buildings have a decided *lean*.

THE REEL DEAL

When actor Richard Coyle, who plays Aberforth Dumbledore, stepped onto the set of the tavern, "it was literally like stepping into exactly how I'd imagined the Hog's Head to be. It was so authentic, I really wanted to just grab a drink and sit down in a corner by the fire. It's a gift to work on a set like that."

The original model of Hogsmeade as seen in the Harry Potter films was scanned and used as the basis for this earlier build-out of the village.

Aberforth Dumbledore

Aberforth Dumbledore (played by Richard Coyle) is the proprietor of the Hog's Head Tavern and Inn. Coyle plays the younger Dumbledore brother, which he states is "an honor."

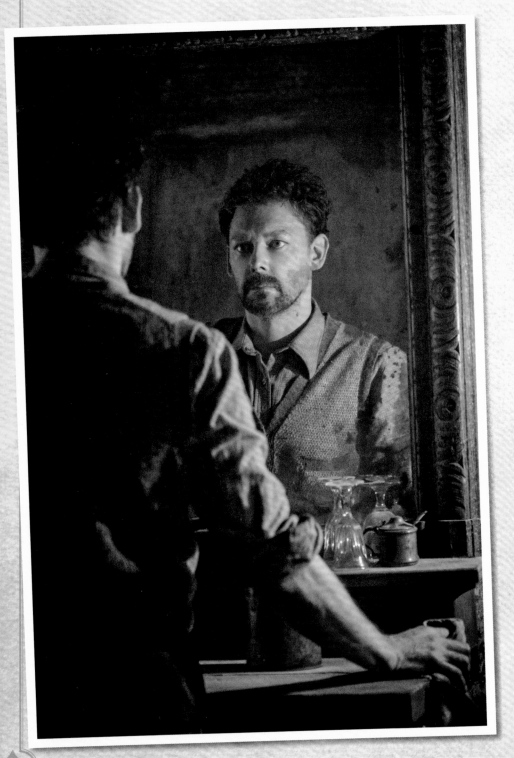

FORCE OF CIRCUMSTANCE

"Aberforth has a huge amount of resentment toward Albus, living in Albus's shadow, his famous, fated older brother, who everybody loves," says Richard Coyle. "As I think of it, Albus as a life force, and Aberforth, in some ways, as a death force. One of the stories of Aberforth's life is he's lost everybody who he ever loved and cared about."

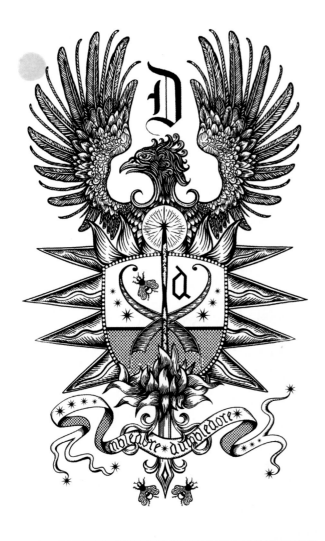

During a conversation with costume designer Colleen Atwood, Coyle reminded her that Aberforth's Patronus was a goat. "And literally, the next day, there was one on the costume," says Richard. "How would you know where to find a goat pin?"

BEARD BROTHERS

Richard Coyle and Jude Law bonded early on, due to their beards and their siblings. "The beards got the conversation started," says Richard. "Then, I have brothers, and Jude has a sister, so we understand the ridiculousness of sibling relationships, and that helped a great deal."

THE FAMILY CREST

Graphic artist Miraphora Mina was asked to create a crest for the Dumbledore family. "We try to bring personality into the design," says Miraphora. "With Dumbledore, we allowed ourselves the freedom to be poetic and whimsical, and let the decoration reflect the person we've come to know over the years." A phoenix represents the family legacy, and a few bumblebees complete the design, as "dumbledor" is an eighteenth-century word for "bumblebee."

INDIVIDUAL STYLE

The philosophy behind Aberforth's wardrobe was that Aberforth should look like a modest version of Albus. "It's like Albus gets his clothes made," Richard explains, "and Aberforth buys things at the thrift store that look a bit like the clothes Albus wears."

Jacob Kowalski

"When you first see Jacob in *Fantastic Beasts: The Secrets of Dumbledore*, he is lovesick," says actor Dan Fogler, who plays Jacob Kowalski. "He misses Queenie so much. The last time you saw him was at the end of *Fantastic Beasts: The Crimes of Grindelwald*, and he's looking off into the horizon, wondering, 'Is she going to come back?' Poor guy. He's still asking that question: 'Where is she?'"

SAD SIGHT

"Jacob is a bit down and out when he comes into the story," says Colleen Atwood. "He's in limbo without Queenie, so we have him disheveled in the beginning, though he did buy a good suit when he opened the bakery." Atwood believes that Jacob is a humble man, and his costume, made in what Colleen calls "working-class materials," reflects that humility.

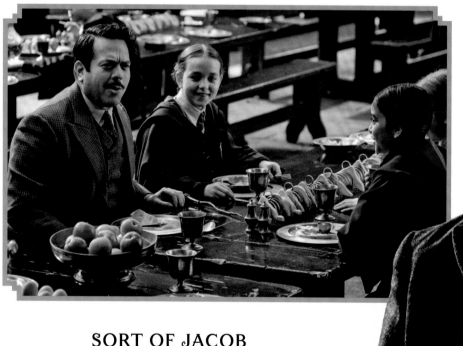

SORT OF JACOB

There was a time when Dan Fogler consulted J.K. Rowling about what house Jacob would have been sorted into had he not been a No-Maj. Dan said to her, "So Jacob's a Hufflepuff, right?" And she told him, "No, no, he's a Gryffindor, because he was a soldier." Dan applied this information to how Jacob might feel about his role in Dumbledore's mission. "Maybe he sees himself as someone who loves baking," says Dan, "but he's a soldier first."

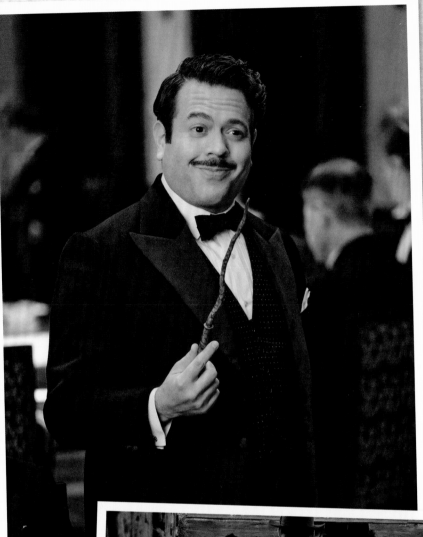

CLOTHES MAKE THE NO-MAJ

At the candidates' dinner, Jacob dresses in a three-piece suit, with matching fabric on his shoes. "It looks like the suit continues down to his feet," says costume co-designer Mark Sutherland. When Dan Fogler tried on the suit and matching shoes, "he was dancing around the room," Mark remembers. "We've never seen Jacob like this—in a dinner suit, bow tie, cuff links, the whole lot, but he has to be up to snuff in the wizarding world."

Dan Fogler considers Jacob to be the good luck charm for his wizard friends. "His heart is so big that he brings good vibes, and that's big magic."

Lally Hicks

Eulalie "Lally" Hicks was seen briefly in *Fantastic Beasts: The Crimes of Grindelwald*, but we finally get to know the scrappy Ilvermorny Charms professor as she joins the team for Dumbledore's mission. Jessica Williams plays Lally, who says of her character, "She's funny, honest, truthful, and really just brilliant. She's great."

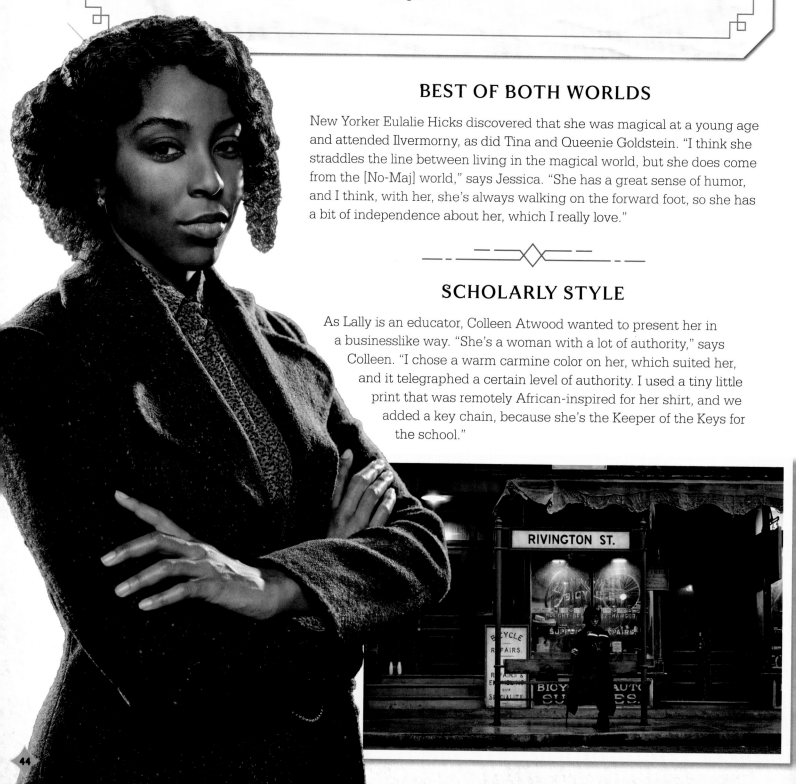

BEST OF BOTH WORLDS

New Yorker Eulalie Hicks discovered that she was magical at a young age and attended Ilvermorny, as did Tina and Queenie Goldstein. "I think she straddles the line between living in the magical world, but she does come from the [No-Maj] world," says Jessica. "She has a great sense of humor, and I think, with her, she's always walking on the forward foot, so she has a bit of independence about her, which I really love."

SCHOLARLY STYLE

As Lally is an educator, Colleen Atwood wanted to present her in a businesslike way. "She's a woman with a lot of authority," says Colleen. "I chose a warm carmine color on her, which suited her, and it telegraphed a certain level of authority. I used a tiny little print that was remotely African-inspired for her shirt, and we added a key chain, because she's the Keeper of the Keys for the school."

BOOK BONDERS

"Newt's relationship with Lally was really fun to play because she has also written a book that people really love, and they bond over that and their respect for knowledge," says Jessica. "She sees the value of what it is that Newt does and she sees his heart. I think overall Eulalie's really good at seeing the heart of people."

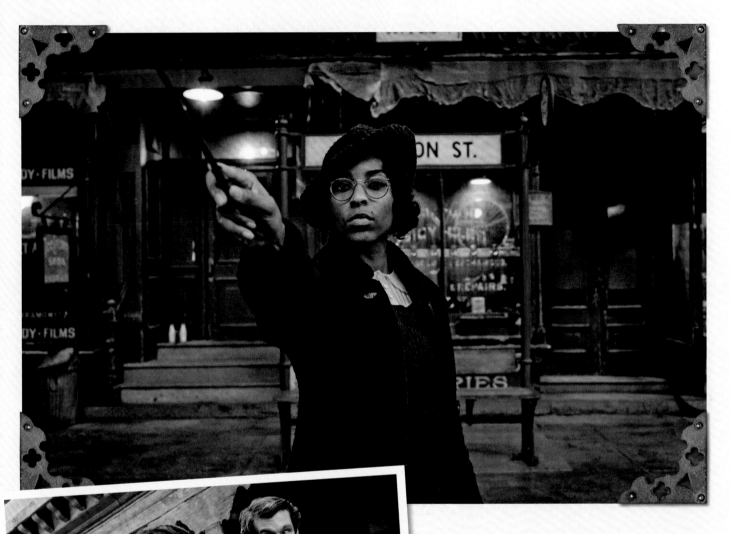

BALANCING ACT

"Theseus and Lally are opposites," says Jessica. "Theseus is very by the book. He's an Auror, he's stern. Eulalie is very sly, witty, a jokester. She's a teacher who uses humor to teach the kids. They're completely different, but they find themselves paired together in this mission, so they're learning the balance of how to work with each other."

A Briefcase of Books

"While at Ilvermorny, Lally threw herself into her books," says Jessica Williams. "She's very, *very* bookish." So, it's fitting that, in Bhutan, Lally carries a case that contains magical books. These will later help Lally and Theseus out of a sticky situation.

THE JOY OF READING

"When we see a script mention a load of books that are not for reading, but that do other things, it's a total joy," says Miraphora Mina. "So much of the wizarding world is about really high design and detail, so we love figuring out what materials to use, what processes and techniques we can do to take the designs into a place the audience recognizes as being a very special world."

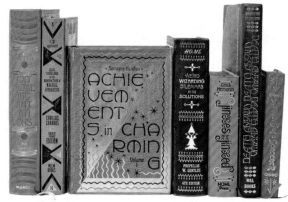

EVERY TRICK IN THE BOOK

During a dustup at the German Ministry of Magic, pages fly out of the book Lally carries and form a bridge to help her and Jacob Kowalski get out of trouble. In addition to providing the content for any pages that will be seen onscreen, the graphics department collaborates with the visual effects team to provide whatever is needed to animate what is normally an inanimate object.

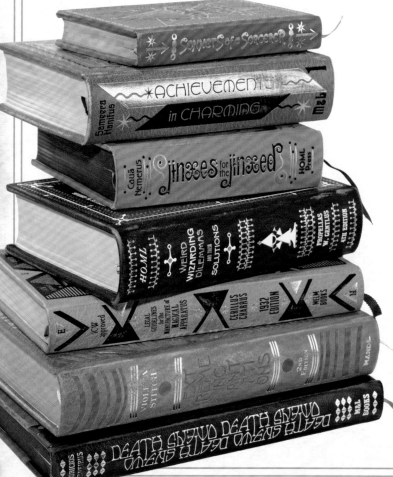

The real-world bookbinding company the graphics department has used for the films over the years is Wyvern Bindery.

IN A BIND

Miraphora Mina and Eduardo Lima have been working with the same bookbinder for the last twenty years. "Standing over their shoulder and watching how they bind the books informs what we can do in our book design, and perhaps, [pushes] the boundaries a little bit each time," says Miraphora. Instead of using leather for the covers, she might ask for a book to be made out of wood, with a brass finish. The cover of one book seen in the films has a cut metal cover featuring silhouettes of Egyptian hieroglyphs, monkeys, and skulls.

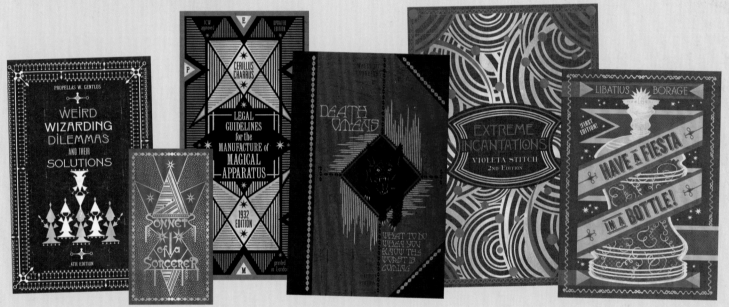

LALLY'S LIBRARY

Achievements in Charming, Volume 1, by Sameera Hanifus, M & L Books

Advanced Charm Casting by Eulalie Hicks, 3rd Edition

Death Omens: What to Do When You Know the Worst Is Coming by Mauricious Carneirus, M & L Books
 [Mauricio Carniero has created sketches for the costume department]

Extreme Incantations by Violeta Stitch, 2nd Edition

Have a Fiesta in a Bottle—Potent Potions for All Wizarding Events and Gatherings by Libatius Borage,
 [Borage also wrote *Advanced Potion-Making*]

Jinxes for the Jinxed: Learn Some Jinxes to Add to Your Arsenal with This Handy Volume by Cauã Nemerus

Legal Guidelines for the Manufacture of Magical Apparatus by Ceailius Charrus (ICW Approved)

Sonnets of a Sorcerer

Weird Wizarding Dilemmas and Their Solutions by Propellas W. Gentlus, 4th Edition

The Great Wizarding Express

The Great Wizarding Express train takes Newt and his team to Berlin. The initial idea for this train was that it would be invisible to the outside world. "But we realized that didn't really feel right in the world of the films," says visual effects supervisor Christian Manz. "The Hogwarts Express is a train you just assume that Muggles didn't see."

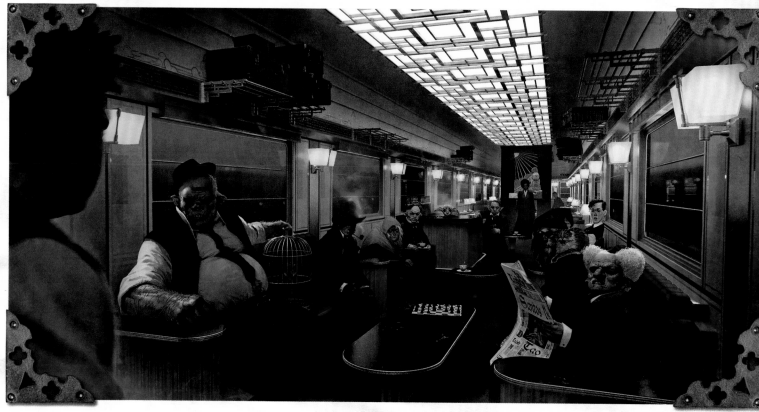

UNDER THE ILLUSION

"There is a tattered old baggage car at the end of this train," Manz says, but inside the train, "this raggedy car has a beautiful interior." The production team visited Germany to scan train carriages authentic to the time, then the visual effects department designed a locomotive and train carriages based on these carriages.

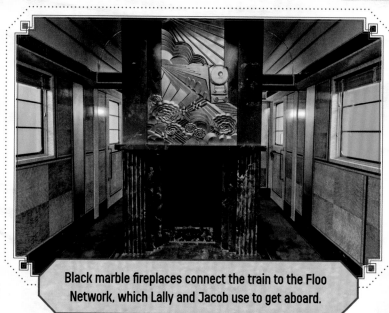

Black marble fireplaces connect the train to the Floo Network, which Lally and Jacob use to get aboard.

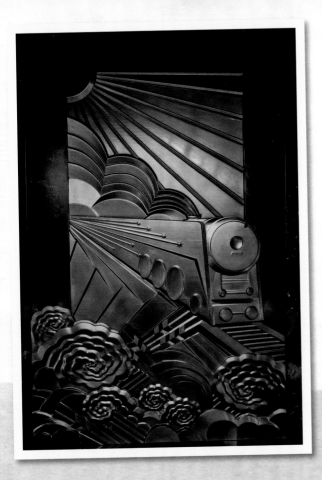

ON BRAND

Stuart Craig and Neil Lamont asked the graphics department to design bas relief panels for the fireplaces. "From that design, we took the logo for the wizarding train company," says Miraphora Mina. The logo also was used on an onboard magazine and train tickets they created. "They might not get a close-up," she explains, "but they help fill that world with the relevant pieces that would've been there."

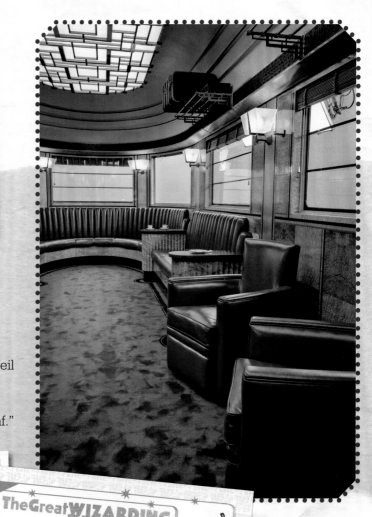

IN FINE STYLE

This first-class observation car has red leather upholstery, a lot of brass, a lot of gold, and walnut veneers with ebony marquetry based on the Art Deco style. "It's quite rich, but in a tasteful manner," says Neil Lamont. "The prop making team made the tables and some absolutely beautiful lamps and wall sconces—where each wall sconce is placed in a shaft of gold leaf."

TROLLEY?

team designed a house-elf viches and cakes. hanna. "The trolley le of sandwiches gh they're probably ling in the corners."

M & © WBEI (s22)

Gathering the Team

"Grindelwald has an ability to capture glimpses of the future, which means he's one step ahead all the time," says Jude Law. "So, the best way to defeat him is a plan wherein no one person necessarily knows what any other person is doing." To that effect, Dumbledore assembles an eccentric but incredibly gifted team of wizards who each bring a different skill set to this mission.

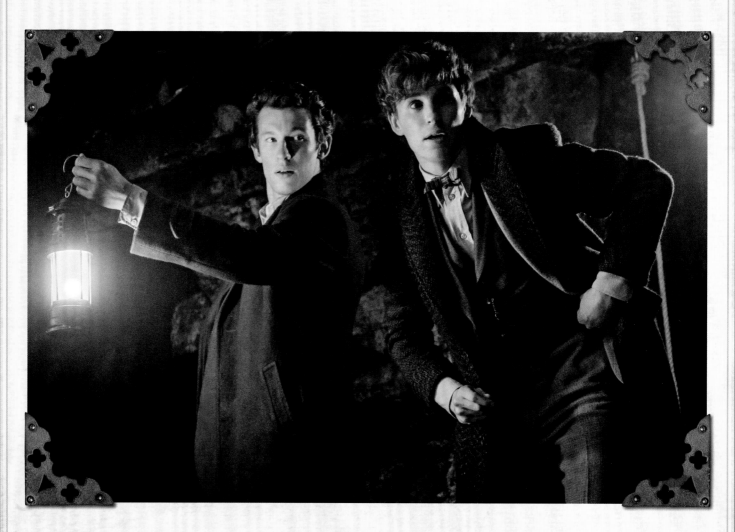

THESEUS SCAMANDER

"The plan is that there's no plan as far as we're concerned, apart from the fact that there is a plan, but we just don't know it," says Callum Turner. "This is excruciating for Theseus, because he wants to be part of the team, but he finds it very hard to trust anyone."

NEWT SCAMANDER

"Newt is tasked with accruing this band of players," says Eddie Redmayne, "but he goes in with unreserved honesty and tells them 'We're not going to know what's going to happen. There is going to be an element of chance here. But have faith in me because I have faith in Dumbledore.'"

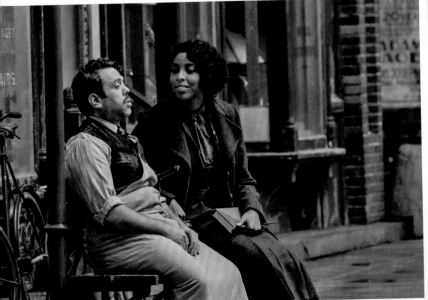

LALLY HICKS

Jessica Williams thinks Lally is there to provide support and to keep things moving. "She has an easier time trusting Dumbledore without knowing the endgame," says Jessica. "She understands that things need to be done because they need to be done, and not only that, this is the right thing to do."

BUNTY BROADACRE

Newt's assistant, Bunty Broadacre, is sent to make copies of Newt's case, which are used to trick Grindelwald and his followers and keep them guessing. "Bunty is quite an artless character," says Victoria Yeates, who plays Bunty. "She's able to complete what's asked of her without other people finding out, because they'll never suspect her!"

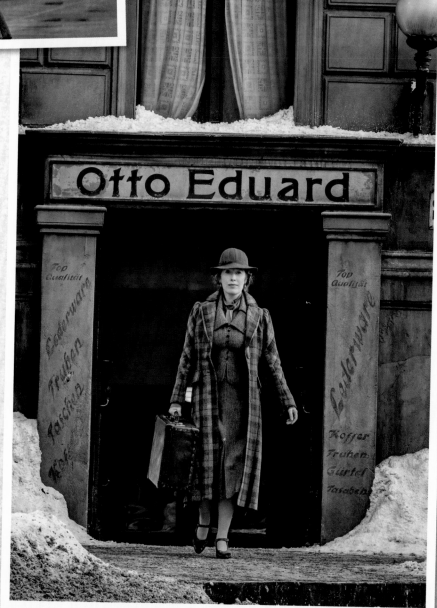

YUSUF KAMA

William Nadylam calls his character, Yusuf Kama, a wild card in the plan. "I don't think anyone was sure whether Kama was good or bad, but Grindelwald's acolytes saw him in Paris," says William. Yusuf is sent to Nurmengard Castle and tells Grindelwald he's spying on him for Dumbledore, which Queenie can confirm. But who is he really spying on?

Dumbledore's Gifts

While on the Great Wizarding Express, Newt Scamander distributes items from Dumbledore that are vital to the mission: a tie and a wand. Two other necessary items—a locket and a book—are already in the hands of those who will use them.

LIKE MUGGLE MAGIC

"On the train, Newt hands out various objects to the team members that are completely odd," says Eddie Redmayne. "He's busy pulling things from various pockets, like an amateur Muggle magician, and I loved that. It's like a seven-year-old trying to do magic, which as a seven-year-old, I used to try and do. I could draw on that very easily."

Jacob Kowalski receives a wand from Newt made from the rarely seen snakewood. "I finally get a wand!" declares Dan Fogler. As part of the storyline, Dumbledore gives Jacob a wand with no core, which cannot actually cast any spells. At the time, Jacob is holding a pan under his arm, which he puts down to take the wand. "It's a lovely scene," Dan says, "and a great metaphor. 'Okay, you're putting down the mask of the baker now and you're taking on the mask of the wizard.'"

Theseus Scamander is given a magical tie bearing the image of a phoenix, which turns out to be a Portkey. First, the graphics department designed the phoenix, which was then silk-screened onto the tie. Several reds were considered before the final color was chosen, then a superfine glitter was added to the ink. "We wanted it to have enough sparkle that it was attractive to Teddy the Niffler, but we didn't want it to be too blingy that it looked weird for somebody to actually wear it," says Colleen Atwood.

Bunty Broadacre receives a small piece of paper with a message inside. Once she opens and reads it, the paper bursts into flames.

Lally Hicks already has a magical book that will be required to execute the plan.

Though not a gift from Dumbledore, **Yusuf Kama** secretly carries a brooch containing a picture of his half-sister, Leta Lestrange, which actor William Nadylam used as inspiration throughout filming. The brooch was inspired by a Victorian piece found by Colleen Atwood. "You don't see it that much," says Atwood, "but for him it's a memento from his life."

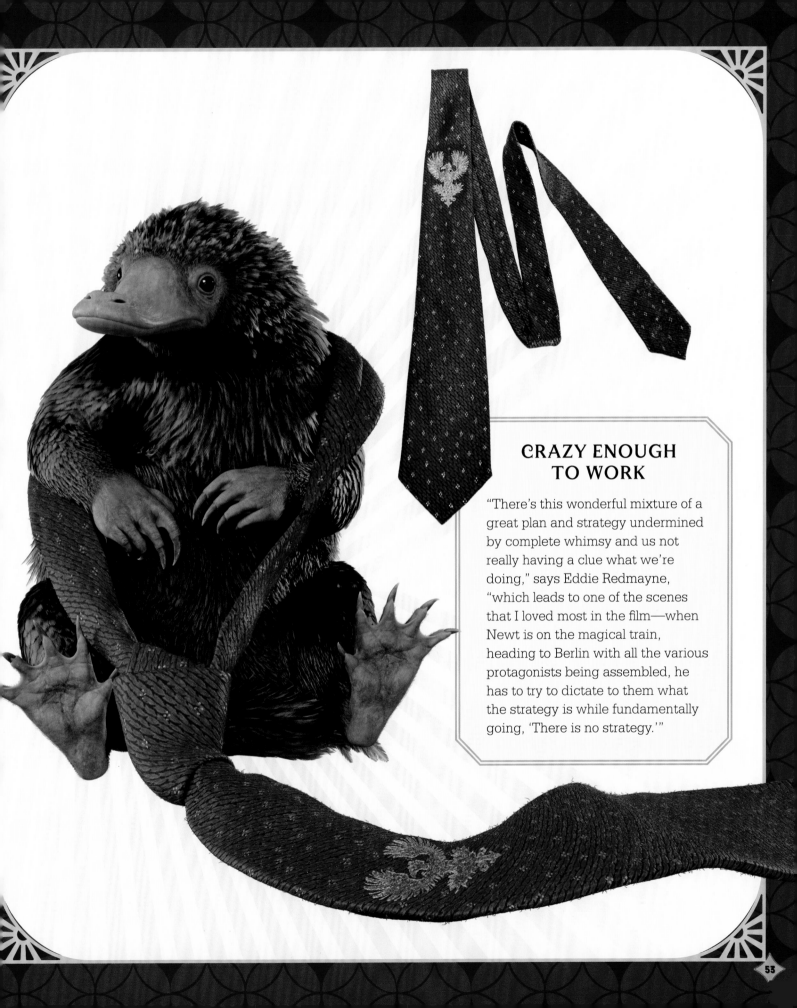

CRAZY ENOUGH TO WORK

"There's this wonderful mixture of a great plan and strategy undermined by complete whimsy and us not really having a clue what we're doing," says Eddie Redmayne, "which leads to one of the scenes that I loved most in the film—when Newt is on the magical train, heading to Berlin with all the various protagonists being assembled, he has to try to dictate to them what the strategy is while fundamentally going, 'There is no strategy.'"

Fantastic Wands

NEWT SCAMANDER

Newt's wand has a simple design, based on the thought that Newt "is a humble guy, so he doesn't have a massively flashy wand," says Eddie Redmayne. The shaft is made from ashwood. "And it bears quite a few scratches and burn marks," he adds, "to get the sense he's traveled the world with it." Junior concept designer Molly Sole worked with Eddie on the materials for the wand's handle. "Newt's very respectful of the natural environment, so the handle is belemnite," she explains. "That's a fossil, an ancient squid, which we thought was appropriate." The handle has a tubular form, with a pearling effect at its tip.

CREDENCE BAREBONE

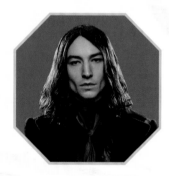

Credence's wand is black ebony, with a six-sided, flat, faceted knob at the tip of its handle. "Credence has a root connection to his wand," says Ezra Miller, "and now has the capacity to direct [magic] intentionally, whereas previously he had no control over it. But it's a destructive magic."

LALLY HICKS

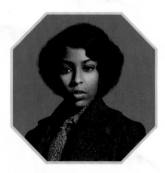

Lally Hicks's wand is one of the most intricately carved wands of the wizarding world. It has a full head and torso as its handle that is a representation of an African goddess, made from African rosewood. The shaft is made from a light ebony wood. "Just a lovely piece to do," says Pierre Bohanna.

ABERFORTH DUMBLEDORE

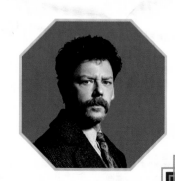

This wand for Aberforth Dumbledore has a long handle featuring tapered and contoured turned wood, topped by a roughly hammered design.

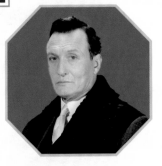

ANTON VOGEL

The wand for the German Minister of Magic has a simple wooden shaft, topped by a silver and gold handle created in a sleek, geometric design.

JACOB KOWALSKI

As Dan Fogler describes it, "The top has been whittled to have a funky knob, and the rest is like a windy branch." Several versions of the wand were created. "There's a bendy one so I don't hurt myself," Dan says with a laugh, "and a wooden one with weight to it. And it was so cool!"

LIU TAO

The wand for International Confederation of Wizards candidate Liu Tao has a light wood shaft divided into three sections by silver bands. The handle is ebony wood, sculpted into a twisting design.

VICÊNCIA SANTOS

Vicência Santos is also a candidate for the Head of the International Confederation of Wizards. The shaft of her wand shows the grain of its wood, while the black-and-white handle features an intricately woven pattern that evokes a basket-weaving design.

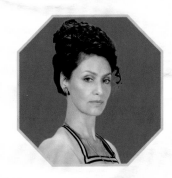

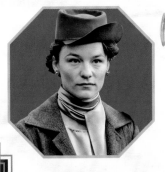

HENRIETTA FISCHER

Henrietta Fischer is an attaché of the German Minister for Magic. Both ends of the handle of her wand sport thick silver caps; in between these are nine beads of wood separated by thin silver bands.

Newspapers, Books, and Wanted Posters

The Fantastic Beasts films offer the opportunity to revisit pieces familiar to the audience from the Harry Potter films, such as wizarding newspapers and books, and even wanted posters.

FANTASTIC BEASTS AND WHERE TO FIND THEM, SECOND EDITION

"Newt's book has been reprinted, so it would be very natural for it to have a new design," says graphic designer Miraphora Mina. For the latest edition, "it still has black and gold as a driving aesthetic in the design, but it's more in the Art Deco style to move it into the thirties. Obviously, any edition is [retrofitted] from what we've seen in Harry Potter," which was an edition from the 1990s.

DIE FLEDERMAUS NEWSPAPER

"Newspapers are great for giving information straight-away about the place, the time, and what's going in that moment," says Miraphora. "And the audience relies on the *Daily Prophet* and other wizarding newspapers to support the narrative where it can in a relevant way." The German newspaper *Die Fledermaus* evokes Berlin in the 1930s with its Germanic stylized typography and design. "We're given a few headlines from the script, but any incidental, smaller stories are up to the graphics department to create," she explains. "So, you'll probably see some Easter eggs about current news, but always in the vernacular of the time period."

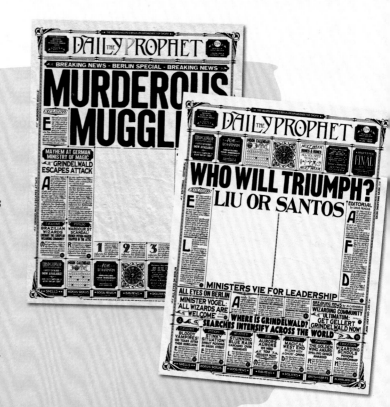

HAVE YOU SEEN THIS MUGGLE?

JACOB KOWALSKI

WANTED FOR THE ATTEMPTED MURDER OF A WIZARD

IN POSSESSION OF A COUNTERFEIT WAND

THIS MINDLESS MUGGLE IS EXTREMELY **DANGEROUS AND VICIOUS**

REWARD 500₸ REWARD

IF LOCATED HE SHOULD BE <u>IMMOBILIZED</u> AND APPREHENDED AT ONCE. THE ICW DEPT OF AURORS MUST BE ADVISED IMMEDIATELY BY OWL

In one edition of the *Daily Prophet*, the entire back page features Jacob Kowalski's wanted poster. "These are fantastic opportunities to support the narrative in a credible way that's still full of magic," says Miraphora Mina.

JACOB KOWALSKI'S WANTED POSTER

While in New York City, Newt Scamander and Tina Goldstein were seen on wanted posters in *Fantastic Beasts and Where to Find Them*. Now Jacob gets one in Bhutan. "The graphic designs for Bhutan have been very specific to the Himalayan region," says Miraphora Mina. Jacob's poster was designed so that it looks as if it probably comes from a woodblock made in a back street in the Himalayas, but with enough elements in it for the audience to recognize that it's still a wanted poster from the wizarding world.

Berlin

Dumbledore, Newt, and the rest of the team arrive in Berlin, where the candidates for the International Confederation of Wizards election are gathering, and Grindelwald presses his claim to lead the wizarding community.

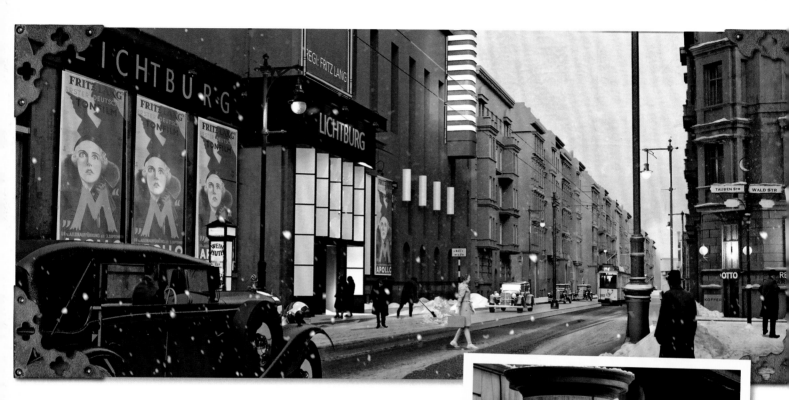

MUGGLE DESIGN

One of the most unusual aspects of Berlin is that other than the central plaza of the German Ministry of Magic, all other exteriors are non-magical. "It's very spare, and quite dominating and oppressive," says Miraphora Mina. "The advertisements on the trams, the street signs, the street names could be mistaken for an authentic location."

STORE FRONTS

The streets of Berlin are lined with non-magical shops filled with merchandise. "We had a camera shop and a travel agent, both of which were fairly new things for the time," says set decorator Anna Pinnock. "The stores then were far more designed; it felt as if the businesses took a lot of trouble over the way the wares were displayed. For our furniture shop, we brought over a lot of pieces from Germany. The shop's windows were so big, it had to be filled with very heavy, overscale furniture."

PERIOD PROPS

"One of the wonderful aspects of these films is that we get the chance to replicate items that just don't exist anymore," says prop maker Pierre Bohanna. "Berlin in the 1930s was very modern [for] its time [and] had lots of incredible architectural elements that we remade, such as illuminated signs and other light fixtures, and telephone boxes for fire engines. Items that you wouldn't have nowadays but bring the period to life."

A ROYAL RIDE

When Grindelwald first arrives at the German Ministry of Magic, he waits in his car, taking in the crowds that have come to support him as he announces his candidacy for Head of the International Confederation of Wizards. For this scene, the prop team located a jet-black Rolls-Royce with a black leather interior, which was originally built in the 1930s for King Edward VIII, later known as the Duke of Windsor. "We put Grindelwald's campaign logos on the doors," says Pierre Bohanna, "and changed the hood ornament to a beautiful flying dragon that forms the [shape] of a G."

Deutsches Ministerium für Magie

The German Ministry of Magic building was inspired by the Chilehaus, a wedge-shaped office building in Hamburg, Germany, designed in the late 1920s, which resembles a ship's prow.

Newt, Lally, Theseus, and Jacob go to the German Ministry of Magic, where Grindelwald makes his bid to become Head of the International Confederation of Wizards, and Jacob is accused of trying to assassinate the latest candidate with a fake wand.

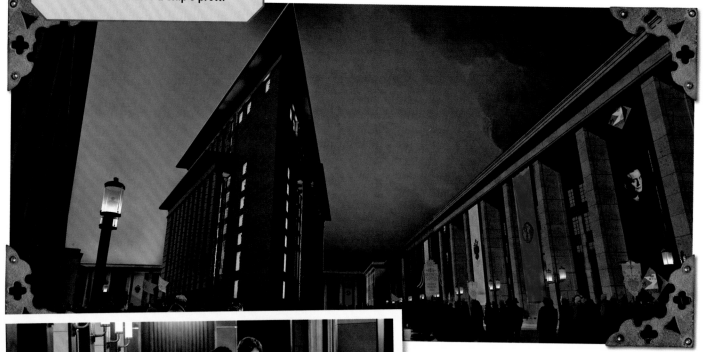

MAKING AN ENTRANCE

The main building of the German Ministry of Magic is approached through a courtyard "in the neoclassical style, and heavily influenced by German architecture of the 1920s," says co-production designer Neil Lamont. "But to get into that courtyard, you have to go through another façade, in an alleyway." The entrance is through an ornate brick wall that features a mural of an eagle.

MAGIE-AUSWEISNUMMER:
11.948.471029.AG

EULENPOST REGISTRIER
1374011

ANTRAG AUF BESUCH FÜR HERR:
Herr Theseus Scamander

ERKSTAG ZAUBERERGE
4191.WS

MEMO

Deutsches Ministe
Be

Sehr verehrter Herr,

Ich möchte Sie hiermit informieren, dass Ihre
wiederholte Anfrage an die Abteilung für de
Magie-Sicherheit weitergeleitet wurde.

Wesentliche Bedingungen für Ihren Besuch :
- Keine Zauberstäbe innerhalb des Gefängnis
 erlaubt
- Alle persönlichen Gegenstände (einschließ
 Geschöpfe) müssen an der Rezeption hinter
 werden
- Wir übernehmen keine Haftung für irreführ
 Wegbeschreibungen durch das Gefängnis

Für weitere Informationen, wenden Sie sich bitte an
die Gefängnis-Richtlinien Broschüre (hier
angefügt).

IHR BESUCH IST NUR AUF 9 STUNDEN, 32 MINUTEN UND
13 SEKUNDEN BEFRISTET - GÜLTIG AB DEM AUSSTELLEN
DIESES BRIEFES.

UNTERZEICHNET, DER LEITENDE STRAFVOLLZUGSBEAMTE

UNTERZEICHNET, DIE AURORENABTEILUNG

UNTERZEICHNET, DEN RAT FÜR MAGISCHE SICHERHEIT

UNTERZEICHNET, DIE INTERNATIONALE ZAUBERERPOLIZEI

118/F

DEVTSCHES · MINISTERIVM · FVR · MAGIE
BERLIN · DEUTSCHLAND

DEVTSCHES · MINISTERIVM · FVR · MAGIE

"It was tempting to use a black letter type for the insignia, which was used in Germany at the time," says Miraphora Mina, "but it was hard to read, so we went for the Art Deco style. Germany was a master of the Art Deco style at that time."

HEROIC DECORATION

The four statues in the German Ministry of Magic were created by sculptor Julian Murray. These were inspired by the German heroic legends of Siegfried, Wotan (Odin), Parsifal, and the Valkyrie Brunhilde, who were immortalized in operas by German composer Richard Wagner. "They've been finished as bronzes," says Neil Lamont, "and then given a verdigris patina to complement the blue-hued brick of the exterior façade."

SEALED UP

Graphic designer Miraphora Mina approached the design for the insignia of the German Ministry of Magic as if she were branding a contemporary organization. "The architecture that was so clearly defined by Stuart Craig in the actual Ministry building really helped serve to bring some visual elements to the insignia," says Miraphora. "There are very dynamic shapes in the architecture that hide a very magical and alternative world behind them." The eagle's profile has an imperial quality to it.

For a Case Chase

Dumbledore's plan is to confuse those who would try to acquire the Qilin by creating four cases identical to Newt's, in a con game Jacob likens to the No-Majs' Three-Card Monte.

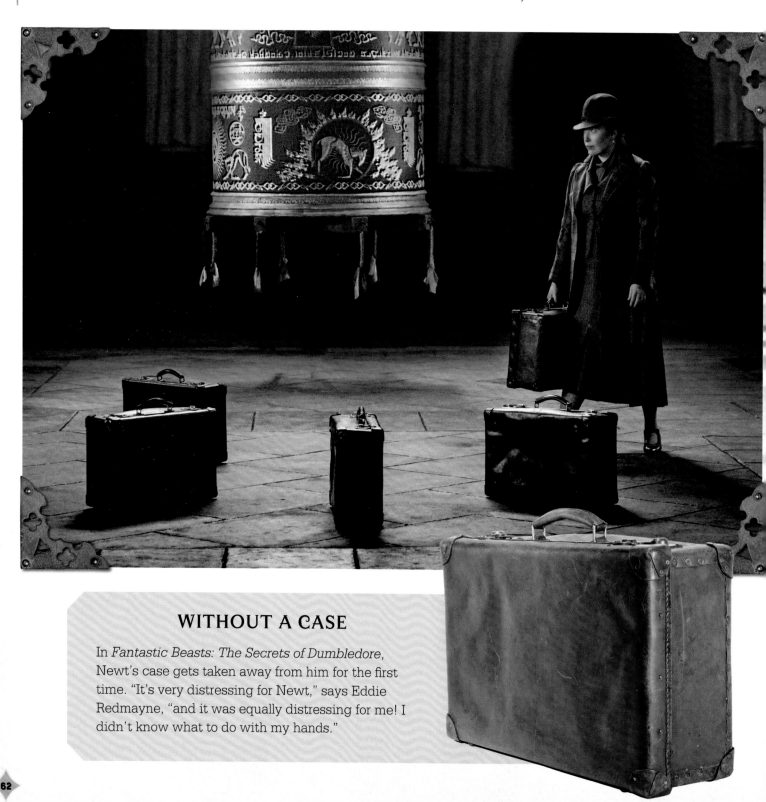

WITHOUT A CASE

In *Fantastic Beasts: The Secrets of Dumbledore*, Newt's case gets taken away from him for the first time. "It's very distressing for Newt," says Eddie Redmayne, "and it was equally distressing for me! I didn't know what to do with my hands."

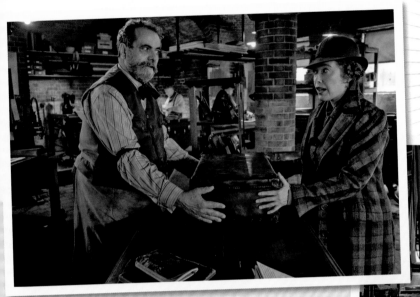

Bunty comes up with an odd explanation for the luggage manufacturer—that her husband, Newt, is absentminded and forgets things; he even forgot he was married to her!

IN DUPLICATE

In his ruse to confuse Grindelwald about which case contains the Qilin, Dumbledore has Bunty make exact copies of Newt's case. "But Bunty hasn't exactly thought it through," says Victoria Yeates. "And Otto, the shopkeeper, asks her 'Why do you need more of these horrible cases? It's completely dilapidated, falling apart.' She tries to come up with a reason on the spot, but she's a really bad liar."

AS THE CASE MAY BE

Eddie Redmayne likens Newt's case to a diary. "It's where he keeps his things, and where he can live," he explains. "He's not with Tina, but her photo is pasted on the case lid, so his heart is very much there. There are drawings that he does when he's out on the road. The case is like a character in itself."

MAKING A CASE

"I know nothing about luggage manufacturing," says set decorator Anna Pinnock, "so I did a *lot* of research." In London, Pinnock found a luggage manufacturer who still uses the same machinery used to make suitcases at the time period of *Fantastic Beasts: The Secrets of Dumbledore*. The cases were not made from scratch but revised per the 1930s technology. The set of Otto's shop was filled by Pinnock with traditional leather-working and suitcase-making machinery.

The Grand Hall

A dinner for the candidates for Head of the International Confederation of Wizards takes place in the Grand Hall of the German Ministry of Magic, attended by Lally and Jacob, several European Ministers for Magic—and Gellert Grindelwald.

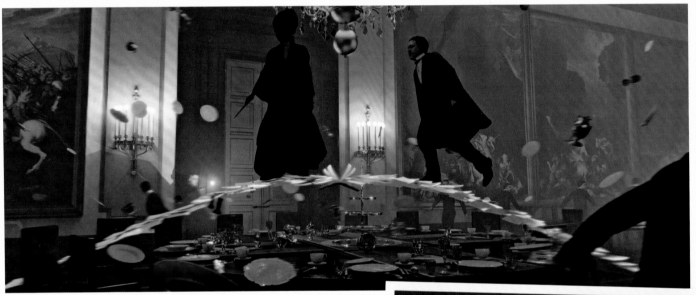

A MAJESTIC MINISTRY

Production designer Stuart Craig studied the large ministerial buildings created in Germany during the early 1930s, many constructed to display artistic and technical achievements. "The interior set of the German Ministry of Magic has these creative touches that give you all the pomp and ceremony of that building," says prop maker Pierre Bohanna, "but with a very magical element."

SEEING IS BELIEVING

Oliver Masucci, who plays the German Minister for Magic, Anton Vogel, was quite captivated by the Grand Hall, especially its tiled floor. "I filmed there for a month and knew this could not be a real marble floor," he remembers. Masucci knew it must have been printed and he looked for repetition in the marbling of the tiles, thinking this was the only way they could have covered that much floor, "but I couldn't find any. Every tile was unique."

A SPARE ROOM

Within the Grand Hall of the German Ministry of Magic, there are two triptych oil paintings that tell stories of the mythology of the wizarding world, featuring unicorns and soldiers riding on broomsticks.

"Just by definition of looking at the reference material for 1930s Berlin, it was very spare in its design," says Miraphora Mina, "so we didn't end up putting many elements inside the Ministry as we did for, let's say, the chaos of [the Magical Congress of the United States of America,] MACUSA. That entailed layers and layers of bureaucracy, manifested through paperwork and wand permits. Layers can help you tell the story, but what you don't have can also tell the story."

BRING TO LIGHT

Prop maker Pierre Bohanna confesses that one of his favorite props to make is chandeliers—and there are four in the Grand Hall. These chandeliers are close in style to the original ones in the Reichstag, home to the lower house of the German parliament in the 1930s. "They're a steel frame with, in theory, electrical lighting," Pierre explains. "Ours have candles with a bulb on the top—two hundred and fifty of these for each chandelier!" Each "candle" had to be individually powered; "an enormous wiring job to do," he adds.

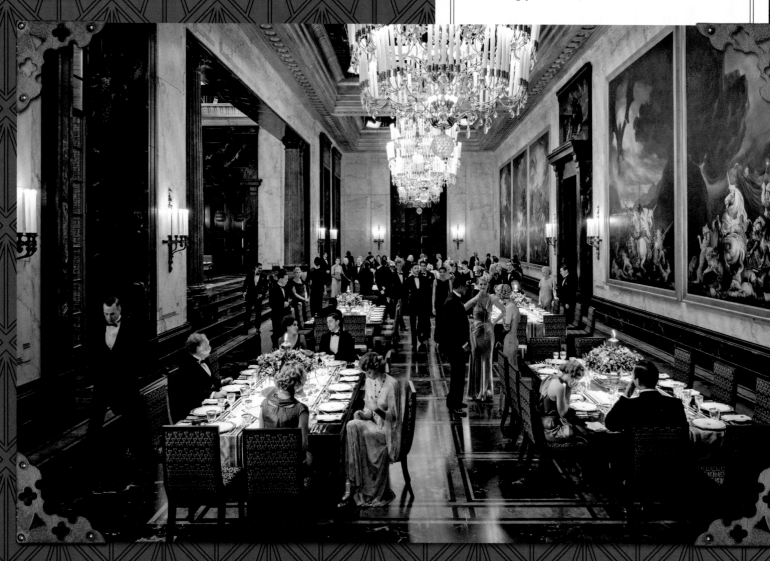

IN THE BACKGROUND

Sharp eyes will notice that some background actors are enhanced by prosthetics. "They don't say anything, they're not referred to," says hair and makeup designer Jeremy Woodhead. "There's no fanfare, but they'll walk through a scene with a strange pair of ears or a strange nose on. They're fun to spot but serve no greater purpose than to broaden the world."

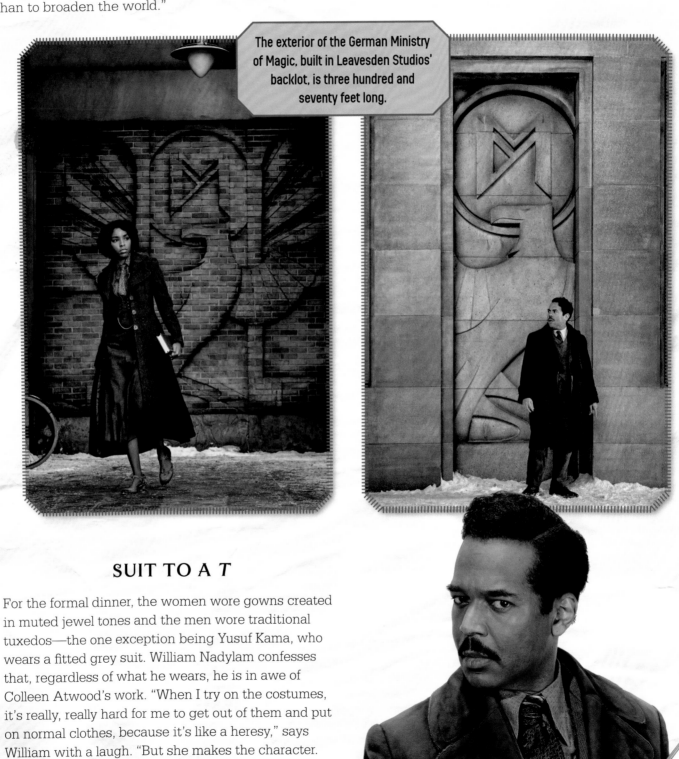

The exterior of the German Ministry of Magic, built in Leavesden Studios' backlot, is three hundred and seventy feet long.

SUIT TO A *T*

For the formal dinner, the women wore gowns created in muted jewel tones and the men wore traditional tuxedos—the one exception being Yusuf Kama, who wears a fitted grey suit. William Nadylam confesses that, regardless of what he wears, he is in awe of Colleen Atwood's work. "When I try on the costumes, it's really, really hard for me to get out of them and put on normal clothes, because it's like a heresy," says William with a laugh. "But she makes the character. Even just trying on the clothes I become Kama."

The Candidates' Banners

With hundreds of wizard supporters between the three candidates for Head of the International Confederation of Wizards, campaign banners are an important visual device to help viewers quickly understand who's got the most support. Color and typography are important for a quick read. "We may only have a few seconds of screen time to impart that information," says Mina.

VOTE GRINDELWALD

For Grindelwald's banners, the graphics team looked at propaganda from the Second World War to inform the styling of the pieces. "It's not just what's on the banners, but the actual shapes and forms that you see," says Mina. The finials atop the German banners were turned to feel almost regimental, and the choices for cords and tassels were deliberate to the time period.

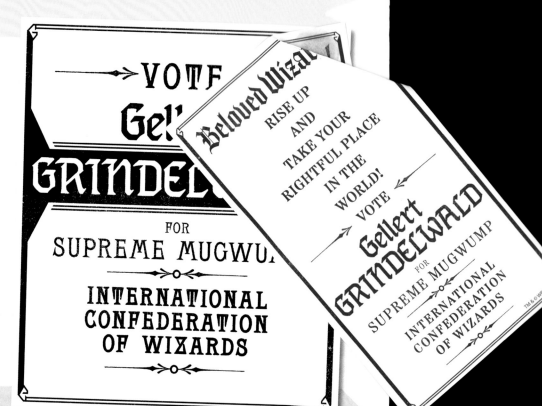

VOTE SANTOS

Graphic designer Eduardo Lima, being Brazilian, had a field day imagining Brazilian candidate Vicência Santos's campaign materials. "There's definitely much more of a spirited feel to that set of banners," says Miraphora Mina. Though each campaign has about four or five different types of ephemera, Eduardo crafted one banner "that could almost be out of a carnival because it's so celebratory," Mina says. He shipped in ribbons, feathers, jewels, beads, and appliqué pieces from Brazil, placed them in layers, and fastened them together with embroidery work. "You can even hear it when it's coming down the streets," she adds.

VOTE TAO

One key imperative was that the campaign banners, posters, and flyers would be authentic to the candidates' countries. The banners for Liu Tao, the Chinese candidate, are on long, thin bamboo pieces instead of wooden sticks, based on reference of bamboo poles actually being used for rallies in China. "Every detail on all these things serves to be authentic to that country," says Miraphora, "but still have the aspect of being in this wizarding space, a little bit of a departure from reality."

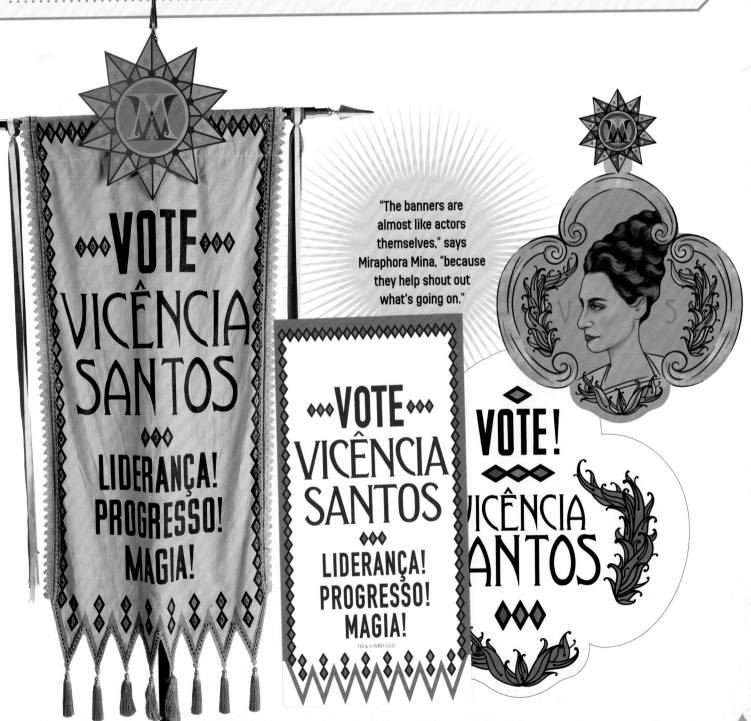

"The banners are almost like actors themselves," says Miraphora Mina, "because they help shout out what's going on."

VOTE VICÊNCIA SANTOS

LIDERANÇA! PROGRESSO! MAGIA!

VOTE VICÊNCIA SANTOS

LIDERANÇA! PROGRESSO! MAGIA!

TM & © WBEI (s22)

VOTE! VICÊNCIA SANTOS

Erkstag Prison

During the Candidates' Dinner in the German Ministry of Magic, Theseus recognizes familiar acolytes of Grindelwald's filling the room—acolytes that were there the night Leta Lestrange died. When he tries to arrest them, he is attacked and taken to Erkstag prison, which was meant to have been decommissioned but is now being secretly utilized by the German Ministry.

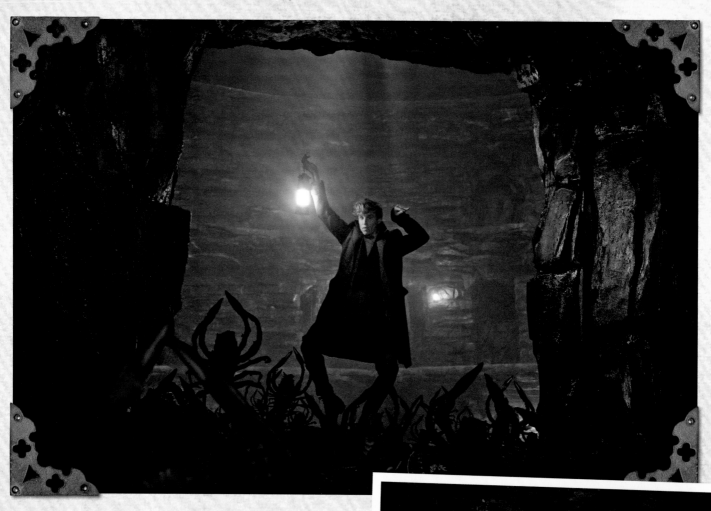

A NATURAL LOW

The production design team found inspiration for Erkstag's constrictive cell block in the quarries of South West England. "One of these featured incredibly square columns in rock that supported a very low roof," says Neil Lamont. "Stuart Craig's always been especially fond of this style of natural set, being cramped and very compressed." Having such a low ceiling, the crew was a bit challenged, but they were helped out with visual effects and creative lighting.

ON THE TAKE

Newt accesses the prison through a U-Bahn (underground transit system) entrance seen on the Berlin set. After descending a huge set of stairs, he encounters the prison warden. "He takes everything from anybody who enters the prison," says Neil Lamont, "so Stuart designed a wonderful pigeonhole wall behind him."

———————◇———————

THRILLS AND SPILLS

...sor Christian Manz describes the sequence ...stag prison as "something between ...essionist filmmaking and a Buster Keaton ...so like a horror film; I don't think we've ever ...g this scary." Erkstag is infested by a huge ...d her deadly babies—creatures that Newt ...able to stop. "But at the same time, we've ...d Pickett staging a daring escape."

HOGWARTS™
SCHOOL OF WITCHCRAFT & WIZARDRY

To whom it may concern,

 I am writing to gain permission for my associate Mr Newt Scamander, to visit his brother Theseus Scamander at Erkstag prison. Mr Newt Scamander wishes to check the well being of his brother, after he was arrested at the ceremony at the Ministry of magic in Berlin, and has since been imprisoned at Erkstag prison.

I hope you will answer my request as soon as possible.

Yours respectfully,

Albus Dumbledore

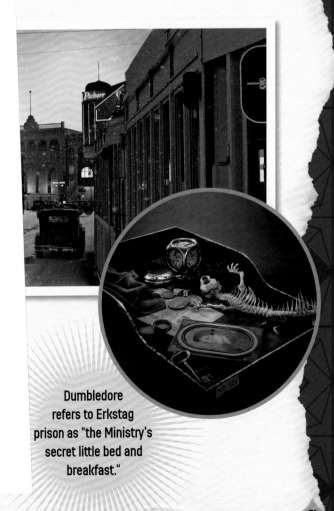

Dumbledore refers to Erkstag prison as "the Ministry's secret little bed and breakfast."

New Beasts: Manticore

Manticores have taken over Erkstag prison. In mythology, the Manticore has the body of a lion and the tail of a scorpion, and it sports a human face. For *Fantastic Beasts: The Secrets of Dumbledore*, the concept artists leaned more toward the scorpion aspect of its appearance.

ADORABLE!

Hundreds of baby Manticores pursue Newt as he looks for Theseus. "When it sits, it's got its tail curled around it," says Christian Manz, "and it's got a little tail wagging. When its little head looks up, it's like a little kitten. But then it sticks out its claws and it's quite obviously insectoid."

CARE TO DANCE . . . AGAIN?

As Newt searches for Theseus's cell, he hears soft skittering noises and then sees a baby Manticore. And then another. And another. As the tiny creatures amass, Newt employs a crablike walk as he makes his way through the corridors. "It wouldn't be a Fantastic Beasts film without me having to go through some ritual humiliation, normally involving a ridiculous dance of some description," says Eddie Redmayne.

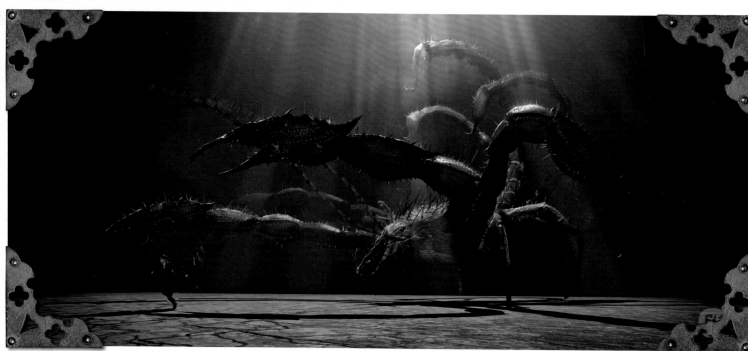

SIDE WALK

"Because we'd done the Erumpent dance in the first film, we wanted to give something else for Eddie to have to do," says Christian Manz. "We came up with the idea of 'limbic mimicry,' where Newt has to do a specific walk that keeps the baby Manticores from killing him." Christian believes that in addition to the tension of Newt and Theseus's escape, "this sequence is all about what would you do to make your big brother look stupid, getting him to do this silly dance."

"The Manticores are these sweet, little crablike things that are obviously in no way, shape, or form sweet!" says Eddie Redmayne. "They're venomous and hideous and disastrous!"

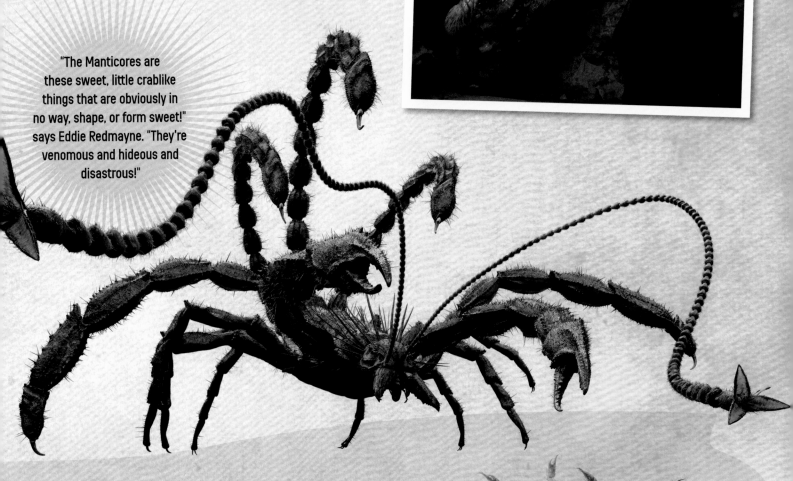

EVERYBODY AND THEIR MOTHER

The mother Manticore poses the most danger as Newt and Theseus make their escape. "Chaos ensues when the mom arrives," says Christian Manz. "We never really do see the mom as a whole creature, because she's so big." To suggest her size, massive stingers and claws thrust out of the pit, operated by the puppeteers.

Old Friends: Pickett the Bowtruckle and Teddy the Niffler

"The great heroes are back!" says Eddie Redmayne. "Teddy the Niffler is stealing the scene, as always, and being the bane of Newt's life. Pickett is being brilliant and helping Newt, giving him a bit of TLC when he needs it."

WHAT A HERO DOES

"Teddy remains one of Newt's favorite creatures," says Eddie Redmayne. "Here, he's incredibly helpful and, as he always does, saves the day with Pickett, who's another complete favorite of mine. I suppose, when Pickett and Teddy read the scripts, they expect some good lifesaving scenes, and they've got them in this film."

SILVER SERVICE

Jacob catches Teddy the Niffler on the Great Wizarding Express and puts him in a frying pan on the carriage's bar. Christian Manz appreciates that director David Yates allows the creative teams the freedom to do subtle but fun actions like that.

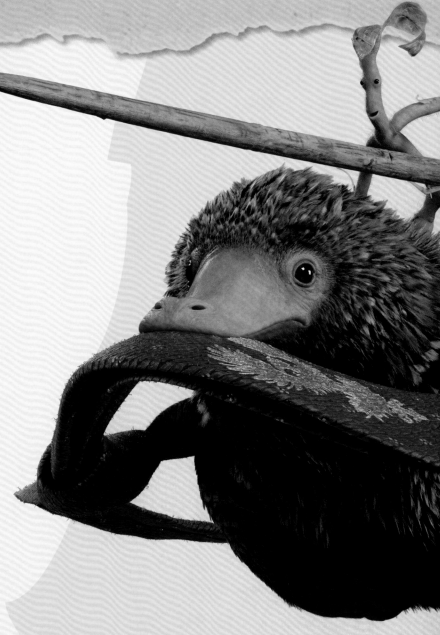

WARM AND FUZZY

The "stuffie" Teddy puppet had a heating pad attached to his belly. "That way, he acts not only as something for the actor as a whole," says puppeteer Tom Wilton, "but also as a [hot-] water bottle to keep them warm on set when we're shooting outside and it's chilly!"

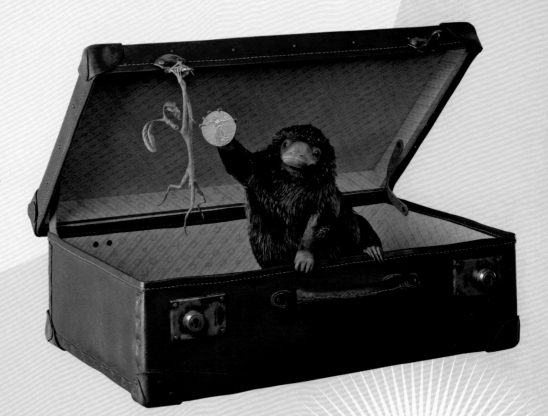

When Newt injures his hand in China, Pickett's hand sports a similar bandage, as he's always trying to mirror the Magizoologist.

PICKETT POSES

"Pickett's back and up to his old tricks," says Tom Wilton. Pickett is realized in a variety of ways—static versions, a version with moving parts, and a Pickett that has a small armature running through it that allows the Bowtruckle to be posed into interesting positions. "When he's holding on to a wand or if he has to hang off something, we can have one arm up and have him rigged to whatever he's holding," Tom explains.

Albus and Aurelius

In *Fantastic Beasts: The Crimes of Grindelwald*, Credence Barebone learned his identity was a lie, and that he is, in fact, Aurelius Dumbledore. When Albus Dumbledore comes upon Credence in the streets of Berlin, a duel ensues where both battle about the truth.

FALSE START

"Credence has been misled and given false leads about who he is throughout his whole life," says Ezra Miller. "The narrative he's been fed is that he was intentionally abandoned and that's why he should seek vengeance on the Dumbledore family. It's totally a fabrication by Grindelwald to motivate Credence's hatred, because he has the power Grindelwald needs."

UNDER THE ILLUSION

The duel takes place in the non-magical world, but Muggles should not be able to see it. So, Dumbledore creates a fake version of Berlin, "a mirror world version of it," says Christian Manz, "where all the signs are literally flopped." Later on, Dumbledore uses his Deluminator to turn off the daylight, so the real world is on the other side, seen through puddles and in windows, a perfect metaphor that things are not what they seem.

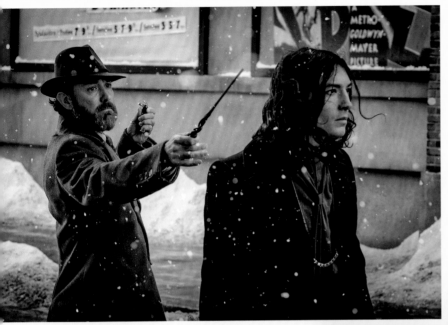

"Dueling Dumbledore was honestly one of the most exciting and incredibly cool experiences I've had," says Ezra Miller. "We put work into finding choreography for the fight that tells both of these people's stories and the story of their collision."

THE TRUTH WILL OUT

As Credence and Dumbledore duel, a phoenix circles over them. "Being a Dumbledore," says Ezra, "the phoenix lets us know that no matter what is being twisted in the way Grindelwald tells Credence who he is, the Dumbledore element is true." Symbolic of the family, a phoenix will come to any Dumbledore who is in need or in distress.

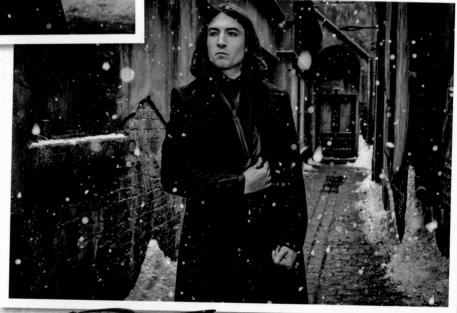

AGE AND ASH

For *Fantastic Beasts: The Secrets of Dumbledore*, the decision was made to have the digitally created phoenix look as if it's toward the end of its lifecycle, so it is less red and vibrant and much grayer than Albus Dumbledore's phoenix, Fawkes. "It does look a little bit worse for wear," says Christian Manz. "Additionally, as it flies, flames come from its wings and it drops ash everywhere, which is part of the story."

The Candidates' Dinner

Before the dinner for the International Confederation of Wizards candidates, Dumbledore asks Lally and Jacob to quell a potential assassination attempt. Jacob sees Queenie at the candidates' table, and as he is a bit intoxicated from drinking from a glass that continuously refills with wine, when he confronts Grindelwald, it's presumed Jacob is the assassin!

SECOND CHANCES

"When Queenie sees Jacob, she can't acknowledge him in order to protect them both," says Alison Sudol. "She's mad at him, but the beautiful thing about her gift is that he doesn't have to say anything. She can hear him, and what he says reminds her that it's not worth surviving if you're not living with love."

Jessica Williams calls Lally and Jacob's escape "cool magic." She practiced the run with a stuntman, "then did it in a gold dress and heels!"

A LITTLE PUSH

"Lally and Jacob have a beautiful relationship," says Jessica Williams. As Lally straddles the line between the Muggle and wizarding worlds, it gives her a unique perspective. "She's very insightful. She sees Jacob's heart and is there to give him a little push into fighting for what he believes in and fighting for who he loves, which is Queenie."

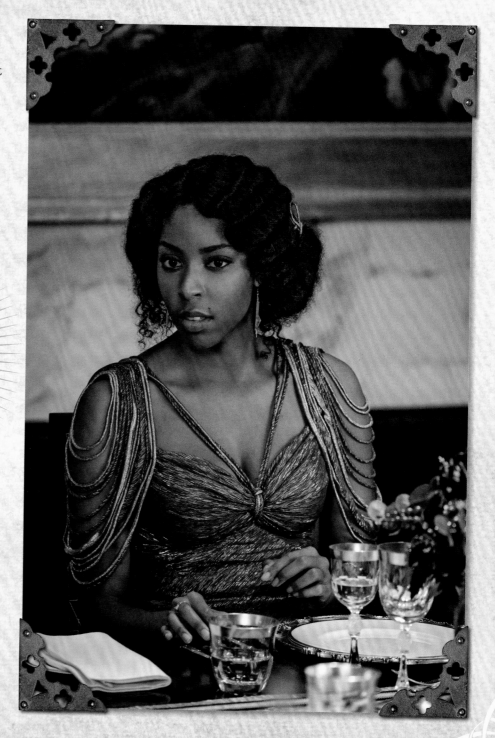

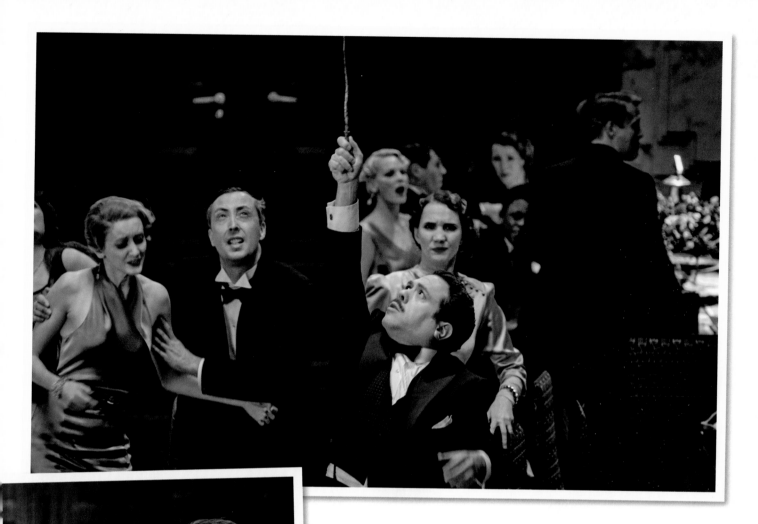

LEVEL BEST

"I get to play so many different levels in the 'assassins' scene," says Dan Fogler. "I'm lovesick for Queenie, I'm drunk, and then I'm angry." Dan likened walking to Grindelwald's table to a Wild West gunfight, with him as the gunslinger. "But then an amazing tornado comes out of the wand, and I'm in a Charlie Chaplin movie, walking against the wind!"

◇

ON THE RUN

Lally escapes with Jacob by creating a massive bridge of books while a storm erupts in the hall. "It's a big slow-motion sequence," says Christian Manz, "with these two running over this bridge while there's lobsters from the dinners flying around and people flying around and wind and rain everywhere. What I so enjoy about working with David Yates is the more absurd ideas you can think of, those are the ones he sometimes goes for."

Return to Hogwarts: The Great Hall and Room of Requirement

As Newt and Theseus manage to escape Erkstag prison with the help of Pickett and Teddy, they grab on to Theseus's gifted tie, which turns out to be a Portkey to Hogwarts. Once there, they join Lally, Jacob, and Dumbledore in the Great Hall.

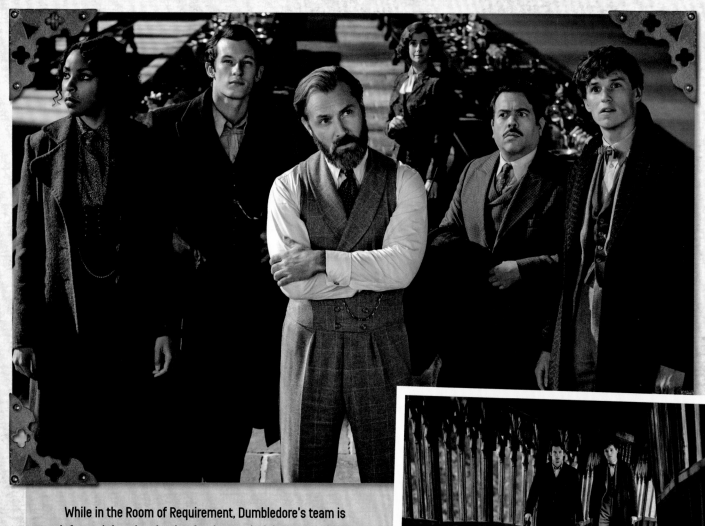

While in the Room of Requirement, Dumbledore's team is informed that the election for the Head of the International Confederation of Wizards will take place in Bhutan, surrounded by the Himalayan mountains. So, the Room features a prayer wheel, which is a Portkey to Bhutan.

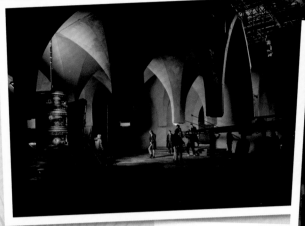

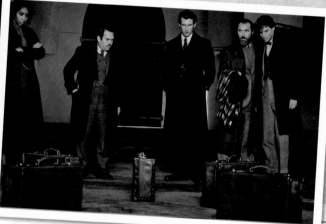

"Being able to shoot in the Great Hall was very special," says Callum Turner. "There were loads of kids there, and it felt very Harry Potter-y and Christmas-y and magical."

A ROOM THAT'S NO ROOM

The scenes in the Room of Requirement and the Great Hall were filmed on "proxy sets." Original scans from the Harry Potter films were used to digitally "rebuild" the sets—the only practical part of the set was the floor the actors stood upon. "It's not CG for CG's sake," says Christian Manz. "We're not in these spaces for very long, so it didn't make sense to build a massive set. We just always look for the best way to do things."

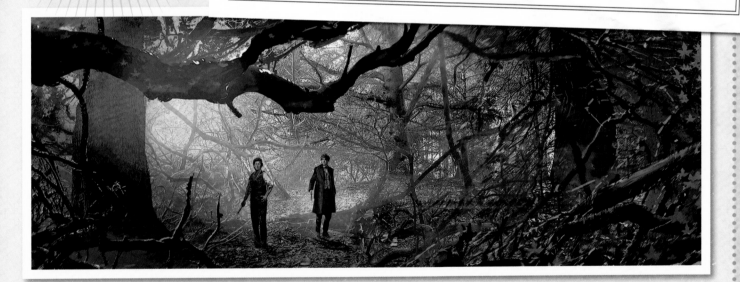

A NEW POINT OF VIEW

Newt and Theseus arrive at Hogwarts through the Forbidden Forest, and viewers will see the castle from a position that's never been shown before. More familiar is the wooden bridge they cross while approaching the castle. The crew went back to the Scottish Highlands to shoot new background plates around Loch Shiel for Hogwarts and Hogsmeade.

PLAIN WORK ROBES

The Hogwarts uniforms seen in the second film were back with very few adjustments. "It's the same period," says Colleen Atwood. "We changed up the shirts and ties a bit, and gave the robes piping to give them a little more color, but stayed traditional with hoods in each house's colors."

The Hog's Head Tavern and Inn

Following a return to Hogwarts, Dumbledore's team assembles in the Hog's Head Tavern and Inn. Bunty arrives first with two young Nifflers, Alfred and Timothy. She is soon joined by Newt, Theseus, Dumbledore, Lally, and Jacob.

BACKWARD THINKING

For the Hog's Head Tavern and Inn, graphic designers Miraphora Mina and Eduardo Lima had to go back in time as they returned to the inn run by Aberforth Dumbledore. "It's the opposite of what [production designer] Stuart Craig did for the Harry Potter films," says Mina. "He got to rethink how things would change as Harry goes through his school years. For this, we're thinking, 'How would a Butterbeer or a *Daily Prophet* or a wanted poster be fifty years *before* Harry Potter, but still be true to that language so that the audience recognizes it?'"

The portrait of Ariana Dumbledore is prominently placed in the Hog's Head Tavern and Inn. It is the same portrait seen in *Harry Potter and the Deathly Hallows – Part 2.*

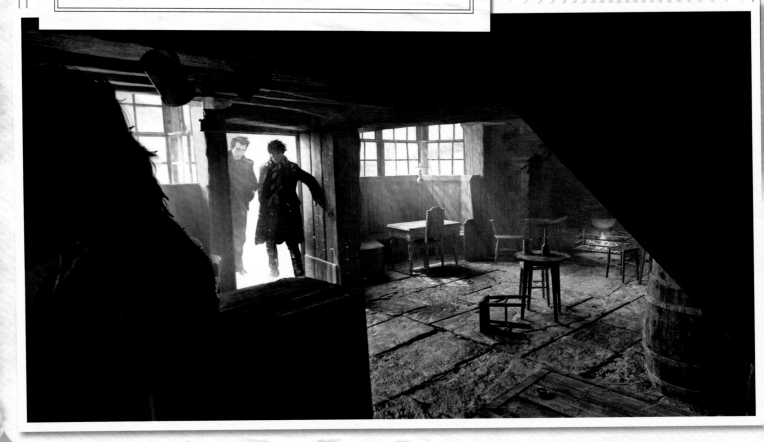

REBRANDING

"It's actually a lovely challenge to have an opportunity to rethink and revisit key props and imagine how they would've been in their previous life," says Mina, speaking of the redesigns for Butterbeer bottle labels and the *Daily Prophet*. Well-known brands frequently change their logos or typography over the years. "And it's interesting to see how brands reflect the styles of their period. Art Deco and Art Nouveau were such defining periods in visual style that it would be disingenuous to not reflect that in any opportunity we have."

GROWING PAINS

The two adolescent Nifflers Bunty is responsible for were babies in *Fantastic Beasts: The Crimes of Grindelwald*. "Oh, those Nifflers are such a pain," Victoria Yeates says with a laugh. "They don't ever do what she tells them to. I was happy to give them short shrift."

Bhutan

Dumbledore's team, the candidates' supporters, and Grindelwald's followers convene in a small Bhutanese village in the Himalayas for the election. This is not a non-magical village, however, but like Hogsmeade, an entire wizarding village.

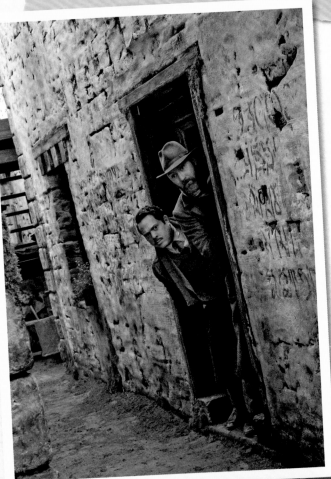

ANY TIME

Director David Yates felt that Bhutan, a spiritual place steeped in tradition, would be a good ending location. "The development of a country of the nature of Bhutan, having a small population and difficult terrain, is a lot slower than [that of] the Western world," says Neil Lamont. Though the time period is the 1930s, incorporating the region's architectural history made it seem timeless.

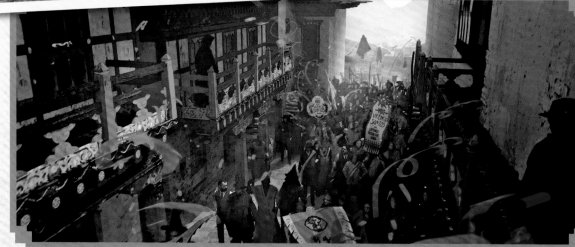

A WORLD OF FASHION

"We had a great time honoring the style and the culture of Bhutan," says Colleen Atwood, "along with the other nationalities we embrace in the wizarding world." The costume department researched what local fabrics and styles would be worn by the inhabitants of Bhutan. "We found that many people wore a similar type of garment they dress up themselves, and can use through different seasons," adds costume co-designer Mark Sutherland.

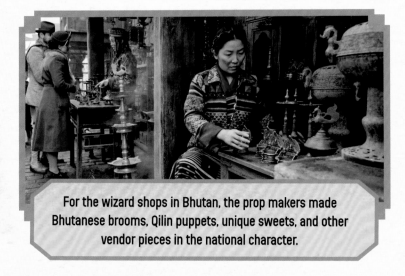

For the wizard shops in Bhutan, the prop makers made Bhutanese brooms, Qilin puppets, unique sweets, and other vendor pieces in the national character.

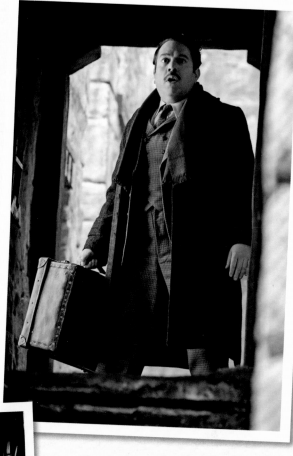

WHAT'S IN THE CASE?

When Jacob's case is opened, a mountain of pastries clogs the streets, perhaps thanks to the Gemino Curse. Theseus's case produces Bludgers, which attack Grindelwald's acolytes. Lally's case contains very familiar books that go after the acolytes—*The Monster Book of Monsters*!

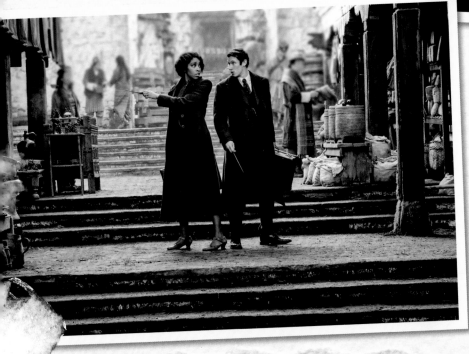

IN PLAIN SIGHT

The streets of Bhutan are where a case chase takes place between Dumbledore's and Grindelwald's factions. The decision to make this village an entirely magical one meant that magic didn't need to be hidden. "For once, we've got our characters running around, casting spells in a magical place," says Christian Manz, "and it's really freeing not to have to think, 'What if a Muggle sees that over there?' We can do anything we want."

Signs, Letters, and Layers

Miraphora Mina, Eduardo Lima, and the graphics team created a kit of symbols, motifs, and decorations that could be used in any aspect of the Bhutanese village, whether painted on a building or displayed on a flag. "The decoration suggests the spirit of Tibetan and Bhutanese design, but it doesn't ever rely on the real world," says Miraphora. "Wherever possible, we put our own slant on things."

PORTKEY PASSAGE

Tickets are required to get to and attend the legendary ceremony in Bhutan. "The tickets were designed with what would have been available in that place," Miraphora explains, "so they're printed on papyrus paper with a rubdown of gold. Quite rudimentary, but very reflective of the place that they come from."

GRAPHIC APPEAL

"Everything about this film is about depth and layering," says Neil Lamont. "With posters and banners, the signages, and the wall murals, it's like an onion, but this onion is enormous!"

TO THE LETTER

The Himalayan wizarding village features a celebrated temple that Mina and Lima named the "Magisterial Chamber of Ancient Wizardry." Mina and Lima designed the temple insignia in an alphabet they also designed. "It visually references Tibetan letter forms but it's usable in English, so that we fall somewhere in between the two," Miraphora explains.

STANDING ON CEREMONY

One of the most important motifs to develop was for the sacred Qilin ceremony, where local wizards display ceremonial flags and hang homemade bunting. "The Qilin is what binds the place together," says Miraphora. "We drew a lot of versions of the Qilin, including the stance it takes when it chooses the candidate, and used that for decoration everywhere, for souvenirs and flags, painted on the sides of buildings, and ultimately in the temple itself."

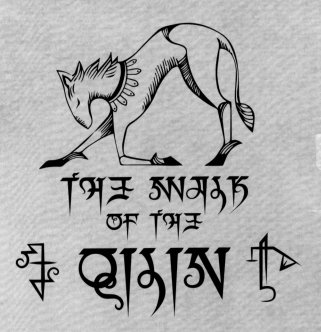

The graphics department designed a Butterbeer label unique to Bhutan.

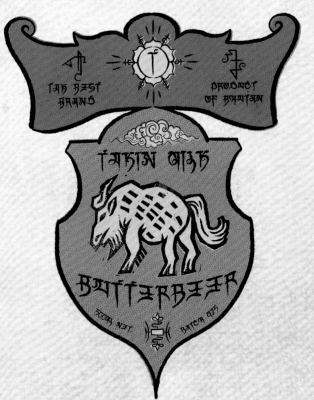

The Walk of the Qilin

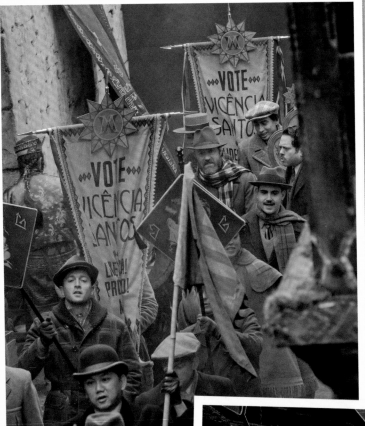

"The Qilin, the most revered creature in this story and world, is what will ultimately choose—without any influence from humans—the ultimate magical candidate," says Miraphora Mina. To that effect, Mina and Eduardo Lima created a mythology of graphics around the ceremony called "The Walk of the Qilin."

"When you look at the Bhutanese architecture, it's absolutely covered in decoration," says Miraphora, "so we decided that the Qilin would be central to the iconography of this wizarding village."

"We definitely felt The Walk of the Qilin is something that happens perhaps every few decades," says Miraphora, "so maybe the inhabitants of this place bring out their own banners and flags that were crafted by them or handed down by their families specific to the ceremony."

The ceremonial banners and bunting that reference the Qilin ceremony are in an inky blue-black with gold embellishments to provide a quick visual reference.

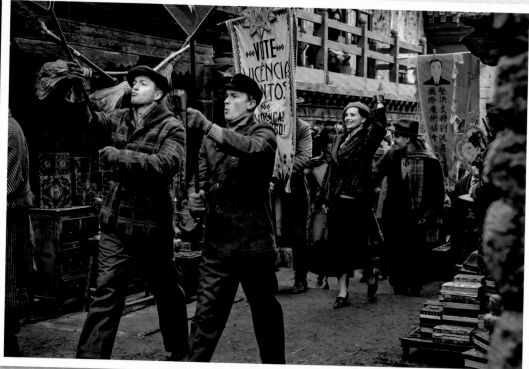

The Eyrie

The Walk of the Qilin takes place in the Eyrie, a sacred space accessed first by Apparating to the Eyrie's courtyard and then climbing an enormous staircase to the top temple level, where the next Head of the wizarding world will be chosen.

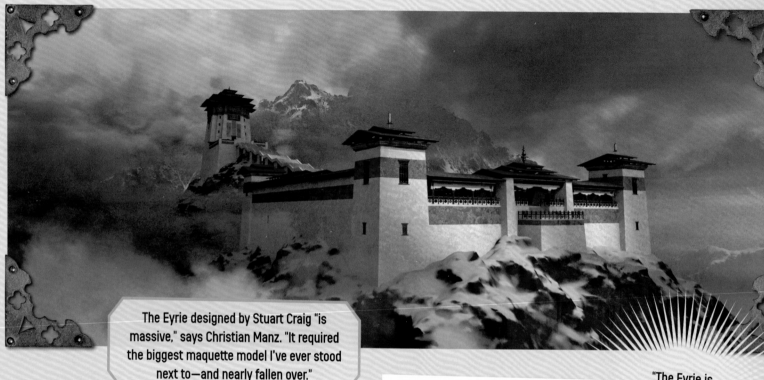

The Eyrie designed by Stuart Craig "is massive," says Christian Manz. "It required the biggest maquette model I've ever stood next to—and nearly fallen over."

"The Eyrie is dripping in gold leaf," says Miraphora Mina. "It's fabulous."

OUTSIDE IN

Over the years, the production company set a rule that if a scene takes place outside, it should be shot outside. "We had to break our rule and shoot it inside because this [scene] was shot in the winter in the UK," says VFX supervisor Christian Manz. Inside the studio, the outdoor temple was not filmed against a blue screen but with a background of the sky and its surroundings projected in. "I think it's going to be amazing, hopefully, to be out in the open in this place that has a sense of magic and mysticism to it."

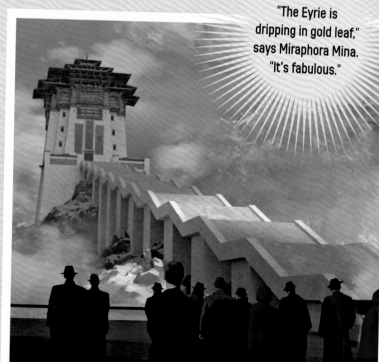

EASY TO FOLLOW

In order to have a quick visual link between the candidates and their supporters in the Eyrie, Tao's followers have Tao's gold or blue colors in their costumes, Santos's have spots of sunny yellow, and Grindelwald's have gray and green. "We needed to have their followers fit in with the environment they came from," says costume co-designer Mark Sutherland, "and have a visual separation between the groups. You can see that in the streets of Bhutan, all these different colors heading up toward the Eyrie. So you know which group is following who."

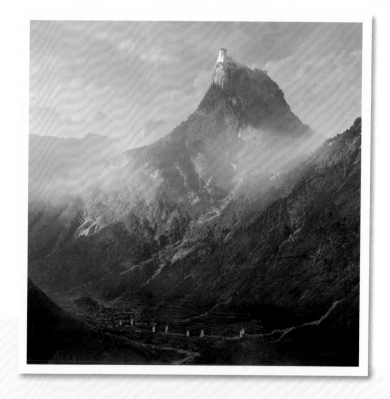

CHAOS THEORY

"There's a sense of embracing the chaos and brilliance that is inside Albus's mind," says Eddie Redmayne, "and what you see is how each of these individual missions and adventures culminate in a confrontation at the end of the film."

Breaking the Oath

When it appears Grindelwald has succeeded in sabotaging the election, Newt and Credence challenge him. In return, Grindelwald challenges them to prove he is a fraud. So Bunty *does*, opening her case to reveal a surprise.

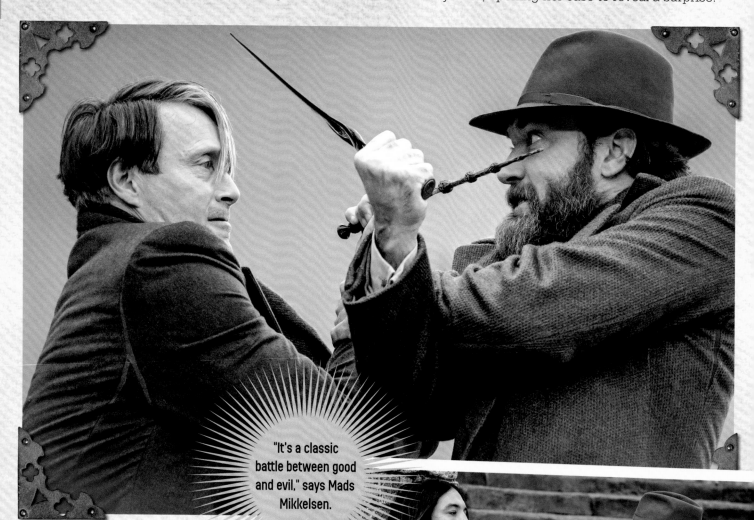

"It's a classic battle between good and evil," says Mads Mikkelsen.

BREAKING THE SPELL

Angry at the turn of events, Grindelwald raises his wand to cast a spell, to which Credence quickly raises his in return. Credence is suddenly protected by a shield form created by both Albus and Aberforth Dumbledore.

A DEVIL

"Mads can certainly turn up the evil," says Ezra Miller. "He's a very sweet and charming and considerate person in life, but the demonic forces are clearly accessible for him, and he was accessing them; oh, yes, he was!"

A DUELER

Jude Law found working the wand duels one of the most enjoyable elements of filming. "The teams that work on these [duels] are incredibly organized and very, very skillful," he says. "It's a case of arriving full of energy, fit and healthy, and diving in, and we had fun doing it."

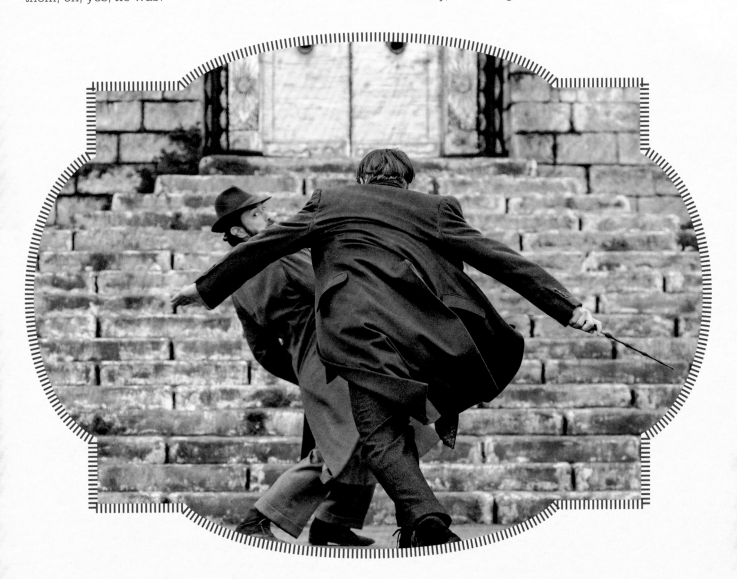

A DANCER

"Mads came in with a beautiful physicality," recalls Eddie Redmayne. "One of the things I didn't know about Mads is that he was a professional dancer. And seeing his physicality was overwhelming for all of us. There was a balletic quality to that movement that was so compelling and jarring and unique, it created something special."

CHOREO-LLABORATION

Every wand duel starts with a blueprint for the physical choreography. "Then the actors start pooling their talents," says stunt coordinator Rowley Irlam. "They take our choreography and work with it to make it their own. It's quite rewarding to put the shape of a fight and then have the actors help to polish it and move it forward toward the end product."

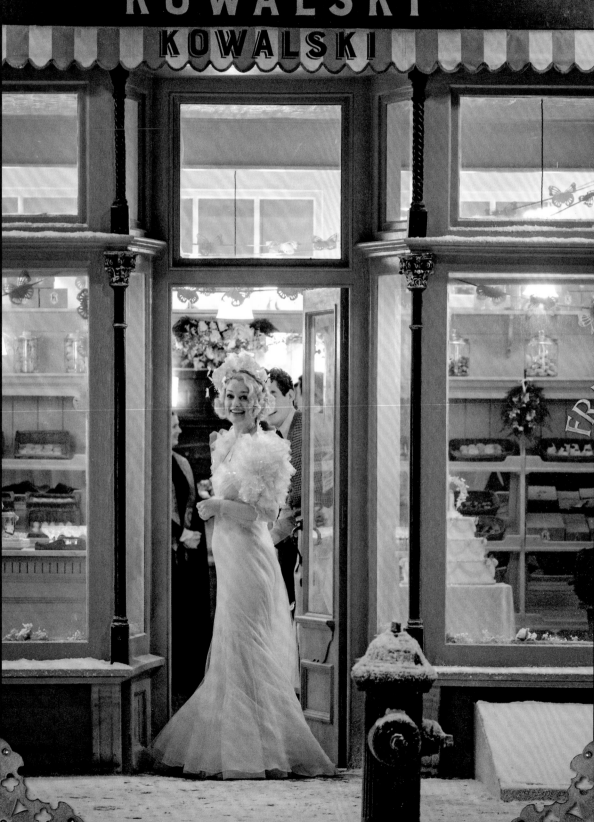

Celebrations

After the election in Bhutan and joyous family reunions, there is another special occasion to attend—Jacob and Queenie's wedding in New York City.

The wedding is held at Jacob's bakery, Kowalski's Quality Baked Goods, decorated with swags of small white flowers and long white lanterns.

Newt, as best man, and Theseus wear a variation on the traditional morning suit worn at weddings, with coat, waistcoat, and formal trousers, in this case, striped.

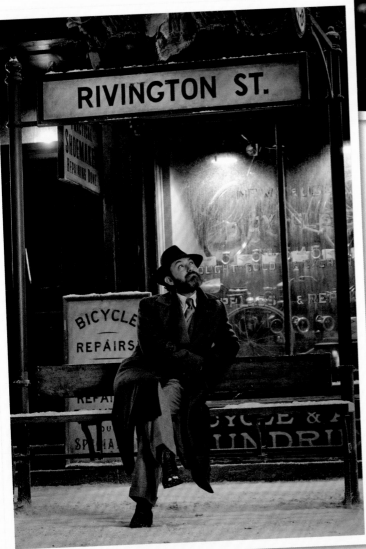

Pickett wears a bow at the wedding not unlike Newt's.

Queenie's wedding dress features a lacey bodice, with layers of lace on her shoulder. Lace butterflies adorn the dress and her headpiece.

Butterflies also hover above a three-tiered wedding cake decorated with pink swags and roses. The bakery's shelves are filled with frosted pastries and chocolate zebra cookies.

As Newt takes a moment outside in the lightly falling snow, the maid of honor—Tina Goldstein—arrives.

Spying Dumbledore at the bus stop across from the bakery, Newt crosses the snow-blanketed street before the wedding starts to share a moment with his former professor, who is appreciative of what Newt has done for him. Newt tells him he will be there again for him if needed. As the wedding begins, they part. Newt races back inside, and Dumbledore heads down the street toward the wintry horizon.

INSIGHT EDITIONS

PO Box 3088
San Rafael, CA 94912
www.insighteditions.com

Find us on Facebook: www.facebook.com/InsightEditions
Follow us on Twitter: @insighteditions

Publisher: Raoul Goff
VP of Licensing and Partnerships: Vanessa Lopez
VP of Creative: Chrissy Kwasnik
VP of Manufacturing: Alix Nicholaeff
Editorial Director: Vicki Jaeger
Designer: Amy DeGrote
Editor: Anna Wostenberg
Editorial Assistant: Grace Orriss
Senior Production Editor: Elaine Ou
Senior Production Manager: Greg Steffen
Senior Production Manager, Subsidiary Rights: Lina s Palma

ROOTS of PEACE REPLANTED PAPER

Insight Editions, in association with Roots of Peace, will plant two trees for each tree used in the manufacturing of this book. Roots of Peace is an internationally renowned humanitarian organization dedicated to eradicating land mines worldwide and converting war-torn lands into productive farms and wildlife habitats. Roots of Peace will plant two million fruit and nut trees in Afghanistan and provide farmers there with the skills and support necessary for sustainable land use.

Copyright © 2022 Warner Bros. Entertainment Inc. WIZARDING WORLD characters, names, and related indicia are © & ™ Warner Bros. Entertainment Inc. WB SHIELD: © & ™ WBEI. Publishing Rights © JKR. (s22)

All rights reserved. Published by Insight Editions, San Rafael, California, in 2022.

No part of this book may be reproduced in any form without written permission from the publisher.

Library of Congress Cataloging-in-Publication Data available.

ISBN: 978-1-68383-717-6

Manufactured in China by Insight Editions

10 9 8 7 6 5 4 3 2 1